WEDDING PHOTOGRAPHY 101

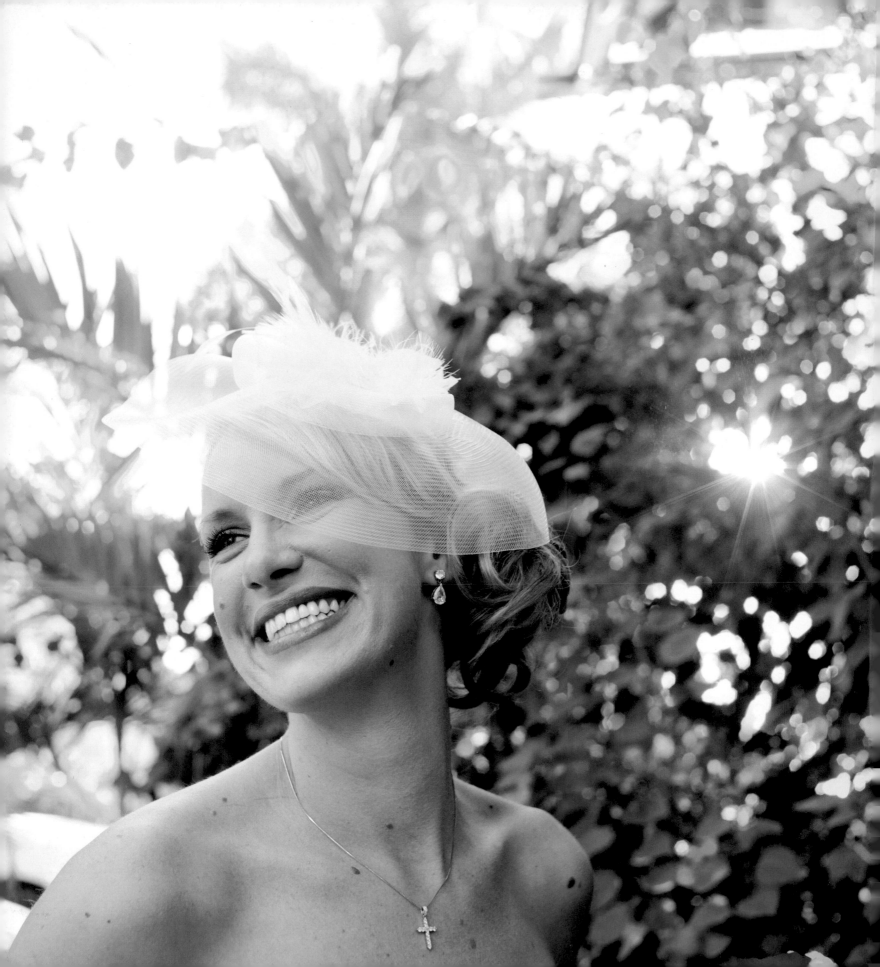

MICHELLE TURNER

WEDDING PHOTOGRAPHY 101

A COMPLETE COURSE FOR NEW WEDDING PHOTOGRAPHERS

ilex

An Hachette UK Company
www.hachette.co.uk

First published in the United Kingdom in 2016 by
ILEX, a division of Octopus Publishing Group Ltd

Octopus Publishing Group
Carmelite House
50 Victoria Embankment
London, EC4Y 0DZ
www.octopusbooks.co.uk

Design, layout, and text copyright
© Octopus Publishing Group 2016

Distributed in the US by
Hachette Book Group
1290 Avenue of the Americas
4th and 5th Floors
New York, NY 10020

Distributed in Canada by
Canadian Manda Group
664 Annette St.
Toronto, Ontario, Canada M6S 2C8

Publisher: Roly Allen
Publisher, Photography: Adam Juniper
Managing Specialist Editor: Frank Gallaugher
Senior Project Editor: Natalia Price-Cabrera
Editors: Rachel Silverlight & Francesca Leung
Art Director: Julie Weir
Designer: Jon Allan
Assistant Production Manager: Marina Maher

ISBN 978-1-78157-344-0

A CIP catalogue record for this book is available from the British
Library

Printed and bound in China

10 9 8 7 6 5 4 3 2 1

CONTENTS

INTRODUCTION

PHOTOGRAPHING A WEDDING IS a rewarding experience, a joyous occasion full of touching moments, beautiful details, and a couple decked out in their finest. It can also be a stressful experience if you don't know what to expect. Whether you make wedding photography your hobby or your career, weddings are once-in-a-lifetime events and you need to be prepared to cover them to the best of your ability.

The world of wedding photography is changing. Gone are the days of the cookie-cutter approach; increasingly, couples are looking for creative wedding photography that will capture the essence of who they are as a couple. They want photographs of the two of them interacting with one another and being spontaneous rather than just another photograph of them looking straight at the camera. Many couples want a dual approach—documentary wedding photography combined with interesting portraiture—and they are willing to give their photographer total creative license to achieve something unique.

OPPOSITE
A modern couple in a classic environment: even in the most traditional of settings, it's possible to find new and interesting angles.

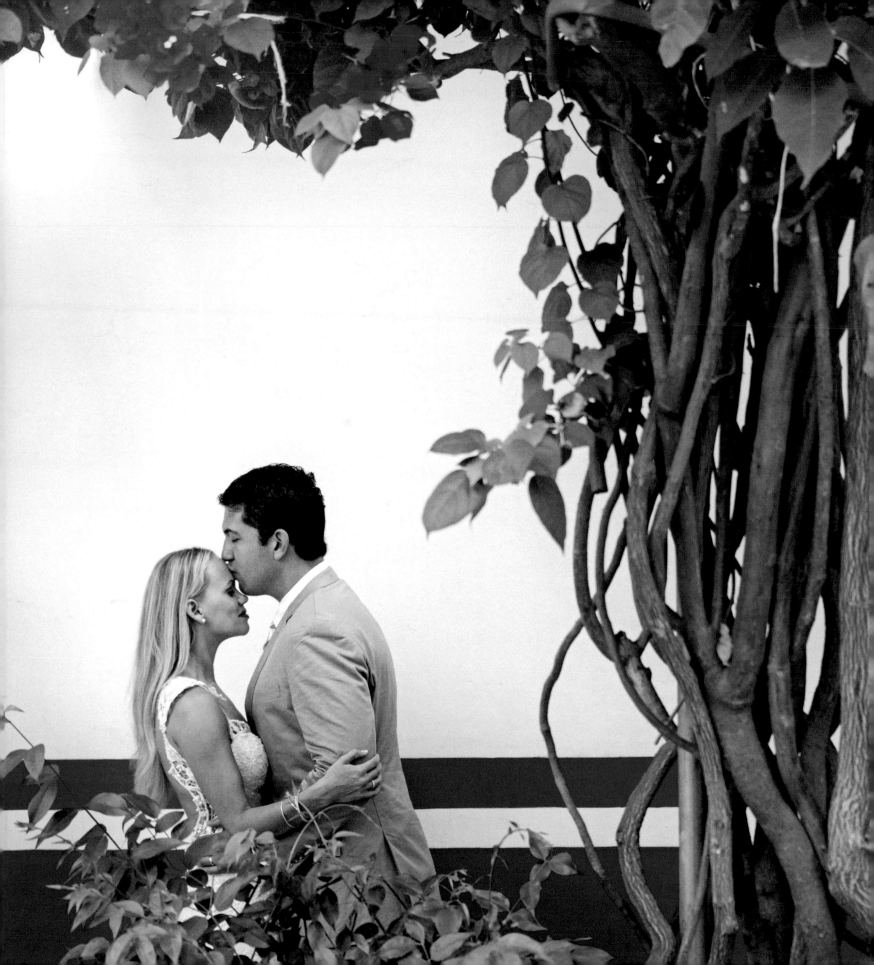

1 GEAR

TECHNOLOGY IS EVER-CHANGING, and as a photographer it can be a daunting task to navigate the jungle of gear on the market from year to year. It seems that every time you turn around a new camera body, computer, or lens is announced with a hefty price tag. With technology constantly on the move, it is sometimes difficult to know where to start and what you need without breaking the bank in the process.

There is no right or wrong kit to buy—mirrorless vs. DSLR, Nikon vs. Canon, prime lenses vs. zoom lenses, Mac vs. PC. At the end of the day, the only thing that matters is investing in a system that works for you. You need to have a system that will help you produce the photographs you most want to capture. Your camera, your lenses, and your computer are only the tools with which you can realize your artistic vision. Simply having the most expensive tools available will not make you a fabulous photographer; the tools are only as good as the person using them. There are many professional photographers out there who could take award-winning photographs using just a disposable camera, so don't get caught up in the "buy, buy, buy" mentality of the industry. Yes, there are elements of your kit that will make your life easier as you shoot a wedding, and yes, there are definitely tools that I wouldn't want to shoot a wedding without, but there's no "one" piece of gear that makes it all possible.

RIGHT
Regardless of the weather, you can capture memorable and intimate shots of the couple. Just make sure you have the right kit and be ready for all eventualities. Creativity is key, as is an eye for the unusual.

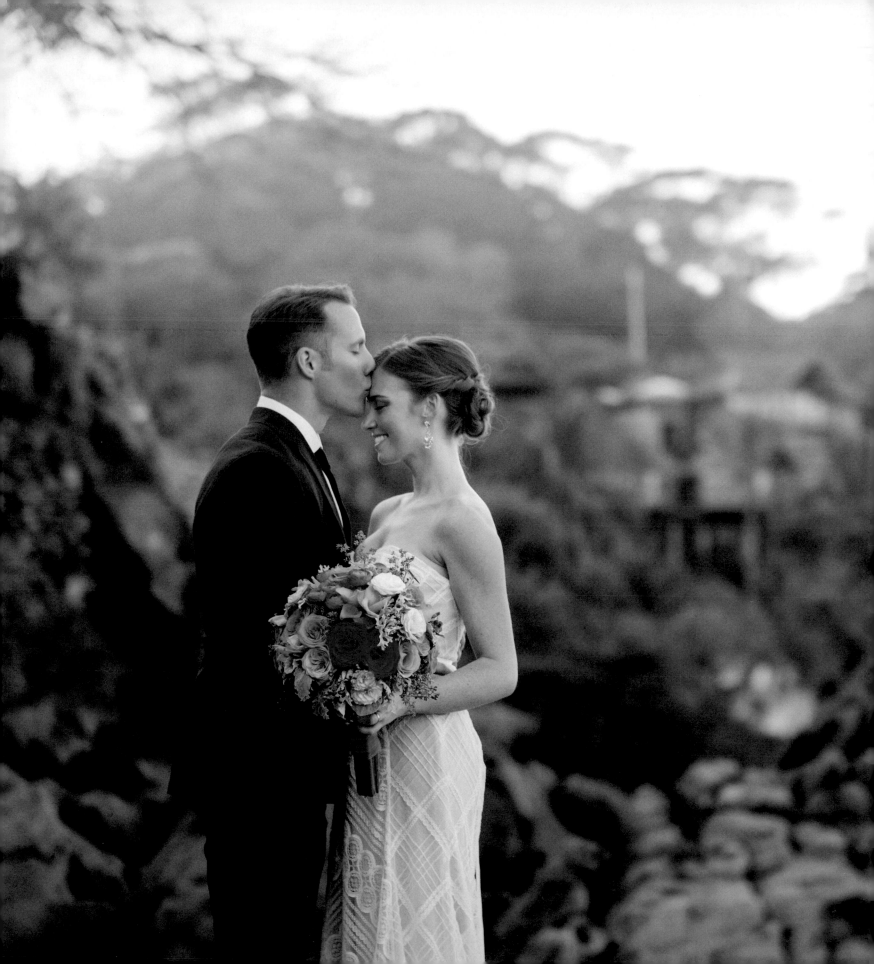

Gear

Before you go out and buy new kit, it is important to assess your needs. First and foremost, know what your budget is. Keep in mind that it is vital to have a backup camera (even two backups) at each and every wedding that you photograph if you are going to be the primary photographer. While the backup does not need to be the same model as your primary camera (and many photographers do spend less money on their backup equipment), you need to be sure that you would be comfortable shooting the entire event on your backup camera. There are no do-overs in wedding photography, and you need to be certain that you have adequate backup in case of an accident (I have had a camera smashed out of my hands on the dance floor before) or equipment failure (I once had a camera fail early in the day, when the bride was putting on her dress). You should also have backups for everything else—your most-used focal lengths, your lights, and extra memory cards. Whether photography is a hobby or a profession for you, it is going to get expensive, so know what you can spend up front and think about the total cost of your kit before you even start building it.

In the following chapters I will talk about the different products available. It is important, however, that you test the gear out yourself to find out what you are comfortable with. There are so many different options available, and the kit that works for you might not be the kit that works for someone else. Find the gear that you are comfortable with and can envision yourself shooting with for an entire day. If possible, rent or borrow a few different systems and test them out in real-world situations before you spend a lot of money. There are many different companies that rent camera bodies, so if you aren't sure what you need, test before committing.

Read reviews on products before you buy, but remember to read a variety of reviews. Talk to the professionals that use the camera systems and look at images from each camera. Fortunately, there are a plethora of websites that are available to help you evaluate cameras, lenses, and computers—for every camera out there, it's likely that you'll find a review from a wedding photographer or organization. My first stop when I'm considering a new piece of gear is dxomark.com. DxOMark will give me the information I want about what I can expect from the gear (chromatic aberration, vignetting, sharpness, etc.). It's a wonderful technical resource. I will then browse for different, less technical reviews. I want to hear how it feels to work with the gear and how reliable it is in the field. Since I primarily shoot weddings and portraits, I'll seek out reviews from my peers. While I love looking at landscape images, a camera or lens review from a landscape photographer is going to carry less weight with me simply because their needs are different. They demand different things from their systems and they use their gear in different ways. I'm going to look specifically for reviews from people who are using their gear in a similar fashion.

There are three essential bits of gear for photographers in the digital age: the camera bodies, the lenses, and the lights. You'll need extras as well, including computers, software, and hardware. The sheer volume of equipment available can be a bit daunting. Hopefully, the next few chapters will help you navigate the world of photography equipment.

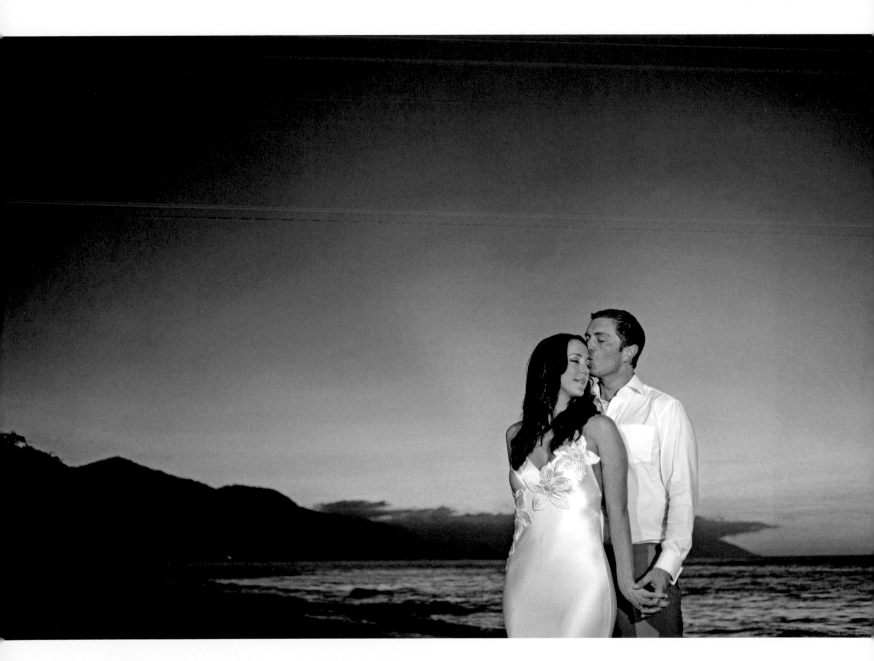

ABOVE
Sunset shots like this require
an external flash in order to
illuminate the couple in the
foreground. Getting the balance
of ambient light and flash just

right takes skill, but you can
practice thoroughly ahead of
time with just about anything.
Never go into a wedding with
untested gear.

CAMERAS

Unless you take photographs with a film camera, it can be incredibly difficult to keep up with the ever-changing camera models.

It seems like there's a new, lovely camera model introduced every month now that the market for professional cameras has expanded from Nikon and Canon to include the mirrorless lines from Fujifilm, Sony, Olympus, and more. The ever-expanding line of cameras has blurred the distinction between professional, prosumer, and consumer models.

The two big players in the DSLR market right now are Nikon and Canon, and (having shot with both) I can personally attest to the fact that they are both excellent. I shot Nikon for almost all of my professional career (more on that in a moment) and I have worked with Canon files of my own (and those from assistants) enough to say that the files coming out of the top-of-the-line cameras from both companies are simply incredible. With updates to the professional, prosumer, and consumer DSLRs coming every year, the cameras and the files that they output are just getting better and better.

While I still pull out my Nikons for an occasional commercial job, I started shooting with a Fujifilm mirrorless system a few years ago and I now shoot most of my weddings with Fujifilm cameras and lenses. Why the switch? I like the unobtrusive nature of the mirrorless system, the smaller footprint, the electronic viewfinder, and the lighter weight that

mirrorless offers. However, all of this combined together would not have made me switch—it was the image quality and the fact that I can have my files mimic beautiful film stocks that really drove me to carry my Fujifilm cameras 100% of the time. My post-processing time is so much faster now that I'm working with files that I like better straight out of the camera.

When you are choosing a camera, it is important to know whether the body has a cropped sensor or whether it is full-frame. Price may also be a factor in your choice. You should also look at some of the other specs on the camera before you purchase anything—for example, what is the maximum ISO? This is one of the most useful specs that I look for when I choose a camera as I regularly shoot at an ISO of 6400 at wedding receptions. What is the sync speed of the camera (an important setting to know when it comes to flash work)? What is the maximum shutter speed? Does your camera have dual card slots? Does it allow you to shoot video? The model of camera that you prefer may be dictated by your answer to those questions. I like shooting at high ISOs with available light, and I like shooting with dual-card slots (I shoot Raw files on one card and JPEGs of the same images simultaneously on the second card), and I need a rugged, weather-sealed camera body since I do a lot of sessions outdoors in the wind on the beach. You may find that your needs are different, so do your research and test out your camera of choice (if possible) before buying.

Today's top of the line DSLRs and mirrorless cameras are capable of creating beautiful images, and the image quality is fantastic up to very high ISOs. I have chosen to use Fujifilm cameras—I use a mix of the Fujifilm X-Pro2 and the X-T1, and I carry an X-T10 as backup.

LENSES

As important as which camera to buy is the decision regarding which lenses to use. As a general rule, I recommend that photographers buy the best glass that they can afford. Why? Because you could have the best camera out there, but if you don't have good lenses it will go to waste.

Choose carefully—the lenses in your wedding kit could cost you more than the camera itself (but they will also likely last you much longer than the camera body), so I would suggest that you rent or borrow some of the different lenses that are available to figure out what would work for you before you purchase anything. There are several great online lens rental companies, and many camera shops that cater to pros offer rental programs.

So which lenses should you purchase? To start, you'll need a variety of focal lengths. Ask twenty different wedding photographers and you'll probably get twenty different answers when it comes to the "best" focal lengths and lenses to have. My two favorite (and most used) focal lengths are the 35mm and 85mm equivalents (so, I use the Fujifilm 23mm and 56mm)—I'll use these two focal lengths the most throughout the day, although I'll reach for something longer during the ceremony and something wider when the open dancing starts.

Prime vs. zoom is a popular debate—I believe that it all comes down to style and personal preference. Primes can have a wider maximum aperture than their zoom counterparts, allowing you to choose a very shallow aperture of up to 1.2. I use primes because I like to shoot with available light whenever possible, and while shooting at an aperture of 1.2 and an ISO of 6400 I can virtually shoot in the dark. I also shoot with primes because I like the shallow depth of field that they give me when shooting wide open, allowing me to throw the background out of focus while my subject remains in sharp focus (although keep in mind that your aperture isn't the only piece of the equation when it comes to depth of field—your focal length and your distance to your subject are equally important). Beyond that, though, I've chosen to work with primes because I also appreciate the lighter weight of them and I often shoot from the hip or over my head. I feel comfortable shooting one-handed if there is a prime lens on my camera body.

I do have some zoom lenses that I'll bring out from time to time. Zooms are wonderful because of the flexibility that they afford. I keep them primarily as backup, but I do use them if the situation calls for it. For example, if my access to the ceremony is restricted or if I have limited mobility during the ceremony for some reason, I might choose to photograph the ceremony with a zoom to help me get a variety of compositions from the different focal lengths I can achieve with just one lens.

I also have a few "specialty" lenses that I carry with me on a wedding day. First, I want to be able to capture beautiful detail images, and I

BELOW

I photographed this venue with a fisheye lens in order to capture the entire scene in an area where I couldn't back up any farther (there was a cliff behind me). I used the lens correction tool in Lightroom to straighten out the image.

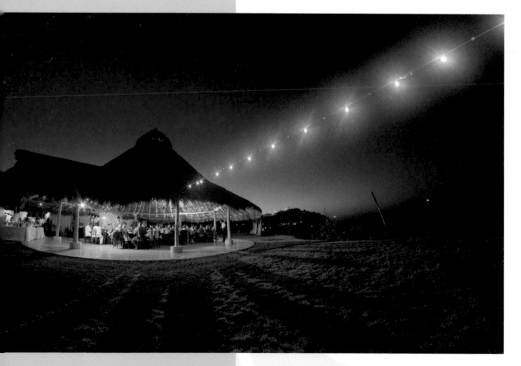

find that when I am photographing the small details (including the rings, the cufflinks, the place cards, and more) that it's useful to have a macro lens in my bag. If weight/money is an issue and you don't want to purchase a macro lens just for a handful of shots each wedding, then you might consider using an extension ring. This will attach to the lenses you currently own and will allow you to convert any lens into a "macro" lens. Generally they are small, lightweight, and inexpensive, to it's easy to add one to your kit. If even that is a stretch, then take a look at the minimum shooting distance on some of the lenses that you already own. Several wider lenses will allow you to photograph a subject that is just inches away—the Tamron line of primes does this very well! Their 35mm and 45mm lenses have very small minimum focusing distances so they allow you to get right on top of your subject. This can be an excellent substitute for a macro lens if you don't want to buy a piece of gear that isn't going to see much action during the day.

I also carry a fisheye lens with me. It's extremely wide and produces a warping, rounded effect around the edges of the photograph. I love my fisheye and I bring it out when dancing starts during the reception. I use a Rokinon 8mm lens with a Fujifilm mount—it's a manual focus lens, but due to the very deep depth of field I can achieve with a lens this wide at f/5.6 and above, I don't even have to worry about focusing on the dance floor (which is particularly useful if it is a very dark dancefloor). I simply keep my camera at a certain distance from my subjects (generally 2-3 feet) and I know that they (and everything behind them) will be in focus. You can run these calculations on a depth of field chart—there's a good one here: dofmaster.com/doftable.html.

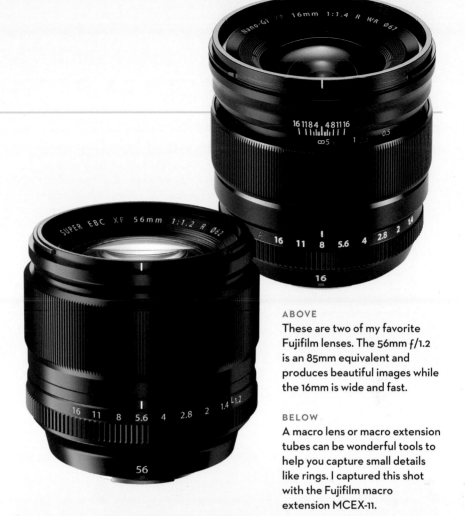

ABOVE

These are two of my favorite Fujifilm lenses. The 56mm f/1.2 is an 85mm equivalent and produces beautiful images while the 16mm is wide and fast.

BELOW

A macro lens or macro extension tubes can be wonderful tools to help you capture small details like rings. I captured this shot with the Fujifilm macro extension MCEX-11.

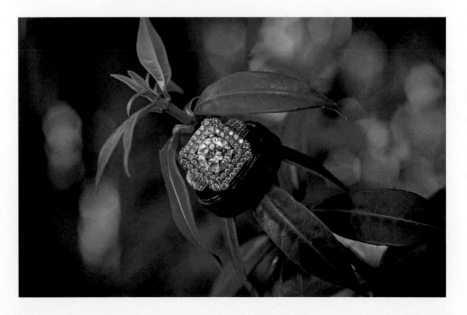

LIGHT SHAPING: LIGHTS, ACCESSORIES, TRIGGERS & RECEIVERS

Even if you prefer to shoot with available light, it is almost always necessary to have something to help you shape the light and/or add extra light to your subject if you need it.

I carry a variety of tools to help me create and shape light. One of the most basic tools is my reflector. I use a sunsilver/white reflector from Profoto (more on this later) to help me bounce some light onto my subjects (or keep light off of them). I recommend that every wedding photographer have a flash or secondary lighting source. My lights are an integral part of my kit and are extremely important to how I work. Most of the time I work with a lighting system

from Profoto. I have both the B1 and the B2 kits, allowing me to take very powerful (and very portable) lights with me on location with no need for a power source. These lights allow me to do everything, from adding a touch of light to my subjects while balancing the ambient light to overpowering the sun. I can light big rooms or small, the recycle time is virtually non-existent (even with a full-power flash), and the system just works—flawlessly, at that—and it's an easy system to learn. Plus, I love the Profoto range of modifiers. They are the best on the market. It's an investment, but it's like buying good glass; camera bodies will come and go, but I'll have my lights for a long time.

If you don't have the budget to purchase expensive lights, I recommend at the very least that you purchase one or two speedlights that you can use on- or off-camera. Not all speedlights are created equal—purchase one of the latest models and you will have an intelligent flash that works well on TTL mode and also allows for full manual control, as well as a flash head that swivels in all directions allowing you maximum creativity when it comes to lighting a reception. However, if TTL is not a necessity for you, then there are many wonderful flashes that will work well on- and off-camera without breaking the bank. If you don't mind choosing a third-party speedlight, there are some great ones out there—I have a few Cactus speedlights, and they work well with my Cactus V6 triggers/receivers (which allow me to use the speedlights off-camera). My Cactus V6 remotes also work well with my older Nikon flashes, which allows me to make good use of all my equipment.

There are many photographers that also choose to work with a video light/continuous light source. This is a great tool for adding a creative touch of light to the scene. There are many models, from a $30 Neewer to the Westcott Ice Lights to the Lowel kits costing hundreds (if not thousands) of dollars.

Once again, your selection should come down to budget, portability, and practicality—

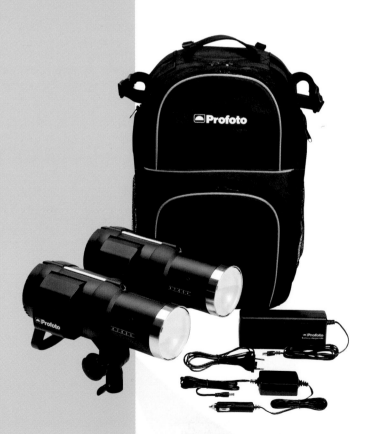

whether you work with an assistant, whether you work on location, and whether you have access to a power source while you are working. We'll cover some specific situations when you'll want to add supplemental light to your photographs later in this book. Whatever you choose—whether you work with one light on-camera, one light off-camera, or several lights spread over a few locations—it is always a good idea to have backup lights on hand as these can and do burn out from time to time.

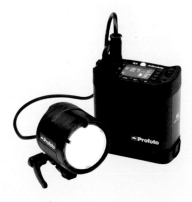

ABOVE
The Profoto Octa Softbox with the grid is one of my favorite modifiers. It creates a beautiful light that is easy to control.

LEFT
The Profoto B2 is a portable and powerful light to bring on location. It is small, lightweight, and easy to pack.

OTHER ACCESSORIES

There are many accessories that you will need when you photograph a wedding. First, you will need to make sure that you have enough memory to get you through the day. I shoot Raw and JPEG files at the same time, and routinely fill over 100GB of cards on a wedding day.

Memory is relatively cheap these days, so make sure that you have enough of it to get you through the day. In my opinion, it is not a good idea to dump your cards onto a computer or third-party device and then erase and reshoot them until you have finished working with the files—occasionally there can be a problem on transfer (a faulty card reader, a glitch in the download, a card error) that you won't be aware of until you really have time to go through the files and look at them. There are some fabulous card-recovery programs out there, but they won't work if you have reshot the card. Have enough memory from the outset and you can avoid any potential problems down the road. Memory cards are not all the same—I use memory cards with fast write speeds, which will allow me to get better performance out of my camera in the field.

Once you have all of the equipment, you need to make sure that you have a way to power it. You will need an adequate supply of camera batteries to power your cameras (I generally change my camera battery twice during a wedding day), and enough batteries to power your flash and/or remotes too. It is also good practice to bring the chargers with you in case you need them throughout the day. I use Eneloop Pro batteries, which work well. Although I have a "slow" charger at home (which recharges the batteries in seven hours and prolongs the life of the batteries), I also bring a fast charger on location in case I need it.

One of my favorite pieces of gear is my ColorSpace from HyperDrive. This allows me to download and verify my cards at the end of an event so that I immediately have a second copy of the images. (This is so important: you should make a second copy of your images and store them in a different location as soon as possible).

Now, how are you going to carry all of your equipment? There are so many bags on the market, and it is important to find a system that is going to work for you. Remember, you need to keep your equipment accessible and secure during the long wedding day, and there are going to be times throughout the event where you will be unable to keep an eye on your equipment yourself. I use several different bags depending on the type of event that I am shooting. If I am traveling to a destination event (requiring a plane trip), then I bring my Lowepro backpack. It's light and fits in any plane's overhead compartment, even on regional commuter jets and tiny eight-passenger planes. That bag has been all over the world with me, and I can't recommend it highly enough. I also carry an ONA canvas bag—I love the gray Bowery bag—as my second personal item on planes. It's my day-to-day bag and allows me to carry a Fujifilm X-T10 with me wherever I go.

On the day of a wedding, I use a Lowepro sling bag. My spare lenses are accessible, and I find that the bag distributes weight nicely across my shoulders. This bag works for me whether I am shooting with my mirrorless Fujifilm cameras or with my heavier Nikon DSLRs. I've been using it for years and I'm on my second version of the bag. It's lightweight and easy to carry.

No matter what bag I'm carrying, I store my memory cards in a Think Tank pouch and clip it to the bag to give me an extra measure of protection. I don't want those memory cards to fall out of my bag on a shoot!

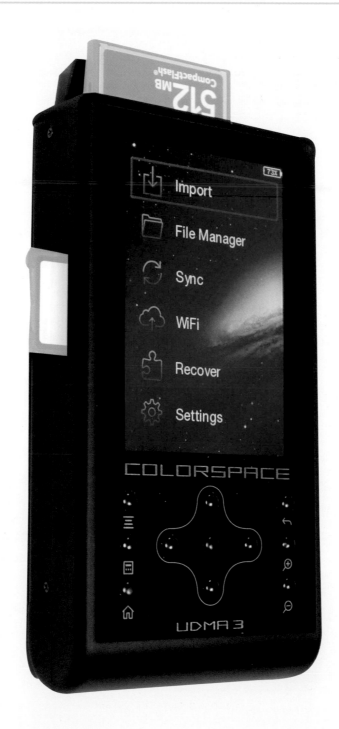

RIGHT

PORTABLE BACKUP
Copying and verifying your cards can be done even before you load your cards onto your computer. You can do it straight after the event with a portable device such as this.

COMPUTERS & SOFTWARE

As digital cameras evolve, file sizes get bigger and bigger. As I mentioned earlier, I routinely shoot 100GB or more of images at each wedding. What does this mean for your computer setup?

It means that unless you want to spend a lot of time waiting for your images to load, you will probably want to invest in a good computer. Mac or PC? As long as you are working with a machine with a lot of RAM, hard-drive space, and quick processing speeds, it really doesn't matter. I've owned Apple machines for my entire professional career and a lot of imaging professionals choose to work with them, but there are a lot of great PC models out there as well. No mater which you choose, make sure that your screen is calibrated (with something like the Spyder Pro) to ensure that the color that you see on your screen will match the colors that you see in your prints.

What else do you need? Once you have processed your images, you will need to back them up. I back up my images to three hard drives (one lives off-site in case of fire) and an online location. To make sure you don't lose work while you are processing your images, you might also consider a RAID setup. It is important to have both, though. RAID protects your day-to-day work while externals protect your long-term work. I perform regular catalog backups and store those online, so I choose

to skip RAID, but you might find that it works for your workflow.

There are several great online solutions out there. I use a combination of Dropbox, PhotoShelter, and Pixieset to store (and deliver) my images, but there are others that you can look at as well, including SmugMug and Zenfolio. Because I don't have a blazingly fast internet connection, I leave the online backup for my Lightroom catalogs and my finished JPEGs. I could never upload my Raw files in a timely manner. Redundancy never hurts, so you should use a variety of setups. Remember, you are working with someone's once-in-a-lifetime memories, and you can't simply plan a reshoot if you lose those files.

You might also consider a dual monitor for your workstation. When I work in Photoshop I like to have my actions and layers palettes readily accessible, but I also like to have my image taking up the maximum amount of space on the screen to make editing easier. I have found that a dual monitor setup gives me the best of both worlds—it allows me to have my images open on one monitor and have my palettes and other useful tools on the other

RIGHT
The MacBook Pro from Apple is the computer that I use for the majority of my work.

FAR RIGHT
The newest Apple iMacs come standard with a glossy screen so you may want to have a second screen for editing. As always, make sure that you calibrate your screen.

screen. You can also use a program like Duet to allow you to use an iPad as a second monitor.

Once you have captured your images, you are going to need a way to process them. The specific programs that you need will depend on what type of image you shoot (Raw vs. JPEG) and what you plan to do with the images. There are many fantastic Raw conversion programs out there—Adobe Camera Raw and Adobe Lightroom are two of the most popular. Fortunately, most of the Raw processors out there have trial periods so that you can test them out and compare the processing abilities and interfaces of each. When I evaluate programs, I take the same set of images and process them through each program. I try to find a program that is both intuitive for me and produces the results that I like most. I have been using Adobe Lightroom since the very first beta version and it's one of the best—I run every image that I take through the program and find the interface to be extremely user-friendly.

For more complex image enhancement, I use Adobe Photoshop (which I'd say is the most popular and versatile program for image enhancement and manipulation). If you are just starting out and are balking at the price tag, you might consider starting with Photoshop Elements, which is a watered-down version of the bigger program. I do believe that Photoshop is an indispensable tool and is necessary for many complex adjustments and for advanced retouching. Of course, there are many actions available to help you achieve a polished image in Photoshop, and we will discuss some of my favorites when we get to post-processing in the latter half of the book.

I also use Alien Skin's Exposure X quite a bit. This program (which works as a standalone or as a plugin for Photoshop and Lightroom) allows me to replicate the look of some of my favorite film stocks—the final look is very customizable, from the pattern of grain to light leaks and enhancements.

TOP
Adobe Bridge is a great program for basic sorting and renaming. It supports batch processing in Photoshop as well as Lightroom.

ABOVE
Lightroom is an excellent tool for everything except complex image manipulation.

CAMERA SETTINGS

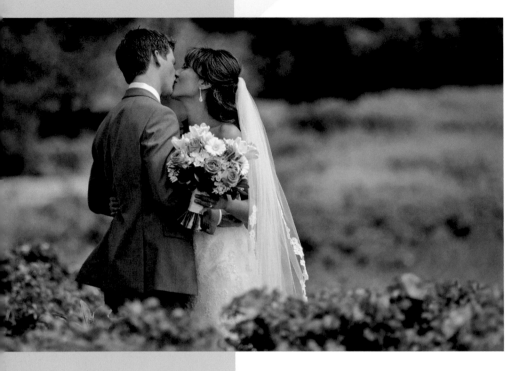

Shooting with a long lens at a wide aperture can produce an image that has a small depth of field—determined by a combination of aperture, focal length, and subject distance.

There are several different things you will need to decide when setting up your camera. The first big decision is Raw mode vs. JPEG? I would recommend that you choose to shoot in Raw 100% of the time. It will give you more latitude when it comes to working with the files.

Whether I am on the job or photographing my kids at their soccer game, I shoot Raw. It gives me so much more flexibility when I "develop" the image. Instead of letting my camera process the file for me in-camera in order to give me a JPEG file, the Raw file keeps more data and therefore allows for more latitude on exposure, white balance, and contrast.

While the JPEG file can also be modified, it has so many more limitations than its Raw counterpart. With sophisticated mirrorless cameras/DSLRs, fast Raw-conversion programs, and cheap memory cards, I really see no reason

not to shoot Raw because the benefits far outweigh the drawbacks. I do shoot both Raw and JPEGs at the same time, but I rarely use the JPEG files. I shoot both for two reasons; occasionally, I will use the JPEGs for quick on-location work (to send an art director an image while on a shoot, for example), and I like to keep the JPEGs as backup files in case something happens to the Raw files.

The second big decision is your choice of exposure mode. Essentially, you have four choices: Program, Aperture Priority, Shutter Priority, and Manual. In Program mode, you are letting the camera decide how to expose the image. You could end up with a wide depth of field and a slow shutter speed in one shot and then a shallow depth of field and a fast shutter speed in the next. I rarely shoot in this mode because of the lack of control that it gives me. It should be noted here that if you have a prosumer- or consumer-model SLR, they will occasionally add more modes such as Night mode or Action mode. These are essentially tweaked versions of Program mode.

In Aperture-Priority mode, you'll set the aperture that you want the camera to use and then the camera calculates the shutter speed. If you want to choose your depth of field (whether you want a shallow depth of field or a deep depth of field) but you aren't comfortable shooting in Manual mode, then this can be a great place to start. Don't forget that aperture isn't the only piece of the puzzle when it comes to depth of field, though. Your distance to your subject and your focal length are equally important when it comes to choosing whether you'll have a shallow depth of field (a sharp subject with an out of focus background) or deep depth of field (a sharp subject with more area in front of/behind the subject that's in focus as well).

In Shutter-Priority mode, you'll set the shutter speed and the camera sets the aperture. If you know that you need a certain shutter speed to achieve the look you want (whether you are including motion in the frame or trying

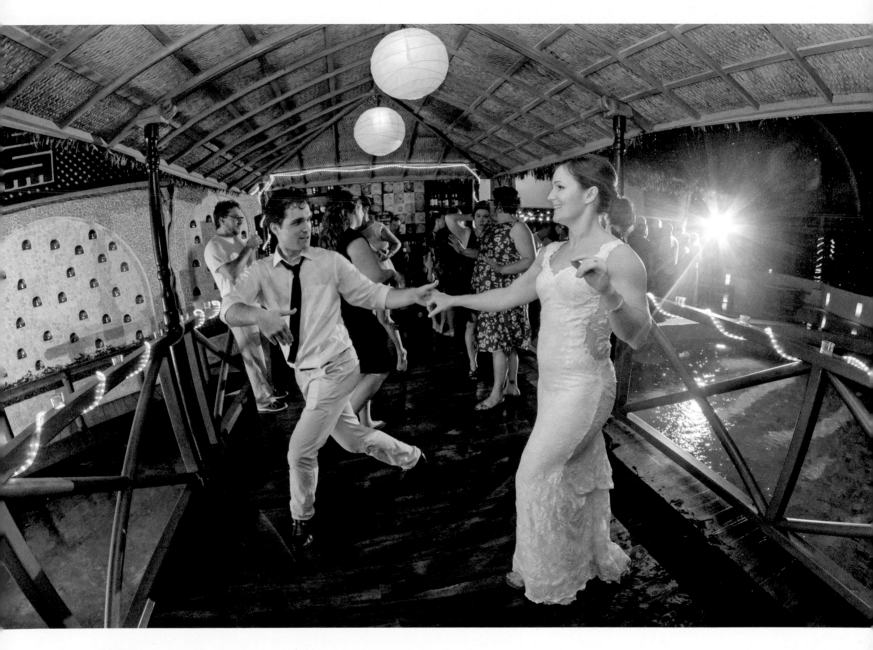

Shooting with a wide lens and a narrow aperture lets you keep a large area in focus when photographing fast-moving subjects in close quarters.

Gear

"New cameras have excellent meters that will help you figure out what your settings need to be quickly and easily"

to stop motion) but you aren't comfortable shooting in Manual mode, then you'll want to consider this setting. There are two types of motion that you'll want to look for: camera shake and subject movement. The general rule of thumb for stopping camera shake (when you have blur due to movement of the camera) is to choose a shutter speed that is the inverse of your focal length. For example, if you are shooting with a 50mm lens, then you'll want to choose a minimum shutter speed of 1/50 in order to keep camera shake from happening. Only you know how steady your hands are, so be sure to take that into account. Of course, vibration reduction lenses can help you slow your shutter speed without inviting camera shake. When I'm photographing a moving subject without flash (flash can help stop motion), then I'll generally choose a shutter speed of 1/250 or faster, if I can. Really, it depends on the speed of the motion (a crawling baby will need a different shutter speed than a race car), whether the subject is moving across the frame or toward the camera (you'll need a faster shutter speed to stop motion for the former than you will the latter), and the distance to the moving subject/focal length.

In Manual mode, you will have total control over the image because you are setting both the aperture and the shutter speed. I use this mode 100% of the time because I like to be in complete control of my camera's exposure. If you've never photographed in manual before, it may seem daunting. Fortunately, though, new cameras have excellent meters that will help you figure out what your settings need to be quickly and easily. I shoot in Spot Meter mode all of the time because I use the zone system to help me determine what my exposure should be. With the zone system, every color/tone in the image has a place that it should fall on the meter and in the histogram. If you know the values for common subjects/objects in your frame, then you'll always know what the "right" exposure should be. For example, a blue sky and green grass read at zero on your meter

with the zone system, while white snow and fluffy white clouds fall at +2 on your meter. You can even learn the meter reading of different skin tones. Most caucasian skin falls at +1, so my boys both meter at +1. My sister in law on the other hand (she is from Kenya and has very deep skin tones), meters at -1.5 to -2. The zone system can be an excellent tool to help you learn how to find your correct exposure in Manual mode. If making the jump still seems daunting, help is available! There are some great online courses that can help you get started shooting in Manual.

The third big decision that you'll need to make is how to set your white balance. There are several white balance modes available, including Auto, lighting-specific modes, Kelvin, and Custom White Balance. Predictably, Auto mode leaves the white balance up to the camera and it's quite good on most of the newer camera models. Lighting-specific modes allow you to select the type of light that you are working with—Daylight, Tungsten, and Flash, to name a few—and will set the white balance accordingly. Kelvin allows you to select the value for the light that you are working with and tweak it by degrees. If you memorize just a few values (for example, candle-light has a value of 1800K while daylight on a sunny day has a value of 5500K), then you'll always have color that is close to correct right out of camera. I use this mode most of the time. Finally, you can choose to set a custom white balance with a tool like an ExpoDisc. Proper use of an ExpoDisc (while it takes a few minutes to set up on the front end) can dramatically decrease your processing times since you'll very rarely need to tweak it. I use my ExpoDisc whenever I can/when I'm not feeling rushed, although I really should make the time to use it more on the day of a shoot.

OTHER THINGS YOU SHOULD KNOW

You have the kit, you have an interested couple, you understand your camera and take wonderful images, but are you ready to photograph the wedding? There are still some things that you should have in place before you photograph a wedding.

Insurance: You are rolling the dice if you are photographing weddings without insurance. Not only will you be hurt financially if your gear gets lost, stolen, or broken (many home-owner/renter insurance policies do not cover camera equipment, especially equipment that is used commercially), but you could also be liable if someone gets hurt because of your gear or while you were photographing them. Let's say that you set your lightstand in the corner of the dance floor and you are happily triggering your external lights with your RadioPoppers while the guests are on the dance floor. Suddenly, one of the groomsmen careens into the lightstand, knocks it over, and it hits someone on its way down. Check the laws in your country, but in the United States you will need liability insurance to protect you from such things. If you are in the US, then you may want to consider joining PPA (www.ppa.com). One of the biggest benefits of membership is this included liability insurance and access to a legal team in case a suit is brought against you.

Contracts: Even if you are shooting the wedding for a family member or a friend or as an assistant to a professional photographer, it is important to draw up a contract, especially if money is changing hands. There are several good pre-made contracts available, but I'm partial to those from the Photographer's Toolkit (www.photographerstoolkit.com). Of course, you will want to have your lawyer take a look at the contract before you use it, since laws may vary in your state, but these offer an excellent starting point and cover all the necessary bases (disputes, claims, delivery, unexpected images—anything that could potentially become a source of conflict). Once you have your

contract in hand, you can either send out paper copies or you can use an internet studio management solution. I currently use ShootQ (www.shootq.com), and it allows my clients to sign electronically and return my contracts, plus it keeps track of billing, leads, and booked dates for me. Another good option is Táve Studio Manager, which essentially does the same thing with a different interface (www.tave.com).

Questionnaires: Both ShootQ and Táve allow you to send your clients detailed questionnaires.

When you first establish contact with your clients you can use these questionnaires to figure out how they heard about you, where they are having their wedding, what their budget is, and who their coordinator is. Once they have booked you, you can use the

"You can use the questionnaire to ask detailed questions about their wedding and about the major players"

ABOVE
The bride arrived with her parents by boat. Having discussed it prior, I knew she wanted one photographer on the boat and one on shore.

questionnaire to ask detailed questions about their wedding and about the major players. Are there any nasty divorces in their families that you need to be aware of prior to photographing the family formals? Are they having any special events? We will review some of the questions later, but keep in mind that there are resources out there that can help you organize your questionnaires within a virtual client folder.

2
PREPARATION

GOOD PREPARATION NOT ONLY ensures you'll have a much smoother workflow during the shoot, it will also be much more fun for you and your client. The more relaxed you are, the better you can direct the bride and groom. Preparation is also key for building confidence. Once you have mastered the basics, you can always cope with the unexpected.

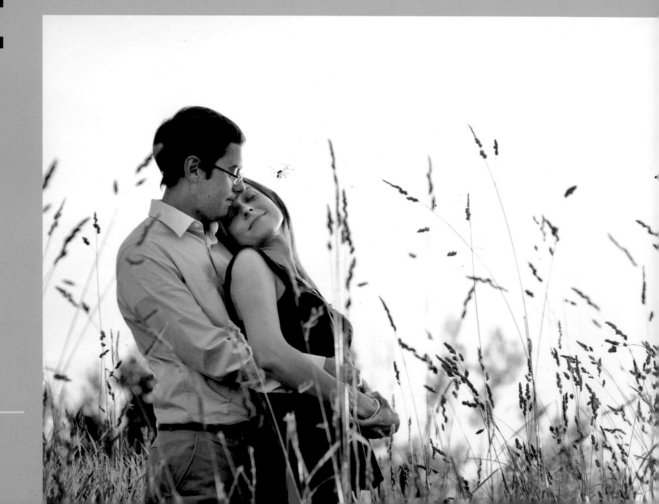

ENVIRONMENTAL PORTRAITS & POSING

I sell myself as a photographer that offers a combination of documentary wedding coverage and environmental portraiture. My clients have carefully chosen their wedding location (whether that refers to the specific venue or the region in which the wedding is being held), and they want to showcase it in their photographs.

I try to loosely pose my clients in a way that allows me to highlight their environment, their details, the weather—anything that will feature the things that make their wedding uniquely theirs.

You will hear a lot of photographers say that they are uncomfortable posing clients. Perhaps it isn't what they love, or perhaps it is outside of their comfort zone. For years now, working with couples to create environmental portraits has been one of my favorite parts of the wedding day. I have broken it down into a series of six easy-to-follow steps so that you can make it more a part of your comfort zone, as well.

BELOW
Getting in tight to capture emotion can be great, but don't forget to capture wide, sweeping shots that highlight the weather, the light, and the location.

Preparation

BELOW LEFT
This couple was married in Mexico so I was sure to capture some images using the colorful walls around town.

BELOW RIGHT
The couple loved this spot on the island so we headed there before the ceremony to grab some photos. I included the entire scene and framed the couple in the shelter.

STEP ONE: VISION

Perhaps the most important step in the process is the first: vision. The vision step is where you see the location and decide on the backdrop for your photo.

Although Photoshop is a later step, this is also the step where you want to visualize your end product. How are you planning to post-process your image? What elements do you want to enhance? What elements do you want to minimize? What is it about that scene that draws you in and would make a dynamic environmental portrait?

For many photographers, when they look at a location, the vision step is instantaneous; they get immediate creative inspiration for what they want to do. However, even the clearest inspiration can sometimes benefit from a bit more thought. Walk around the scene. Look at it from different angles and examine the light. Where do you find the best light and the best backdrop? How will the light (and backdrop) affect your exposure? When analyzing a scene, I tend to look at several different things:

Shadows: Is there an interesting shadow pattern that makes the scene more intriguing? If so, how can it be enhanced or played up in the photograph?

Repeating Elements and Patterns: Is there repetition in the frame? If so, how can I emphasize it to create a more dynamic photograph?

Leading Lines: Are there strong leading lines in the frame that will strengthen the image? How can I frame the photograph to make the best use of those lines?

Reflections: Can I make use of a reflection in the photograph to create a more interesting composition?

Symmetry: Are there any natural dividers in the frame? How can they be used to make the photograph more dynamic?

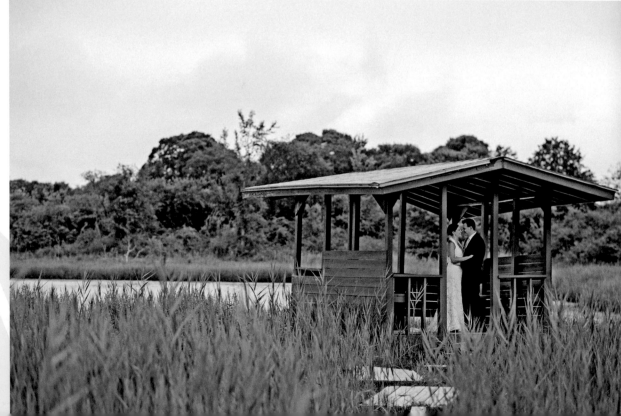

BELOW LEFT
It was easy to place the couple between the beautiful green leaves and the bright green grass on this sunny day.

BELOW RIGHT
I wanted to capture the essence of this village in the Dominican Republic so I framed the couple at one of the local shops.

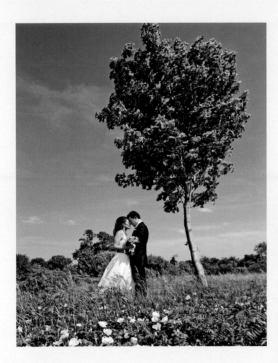

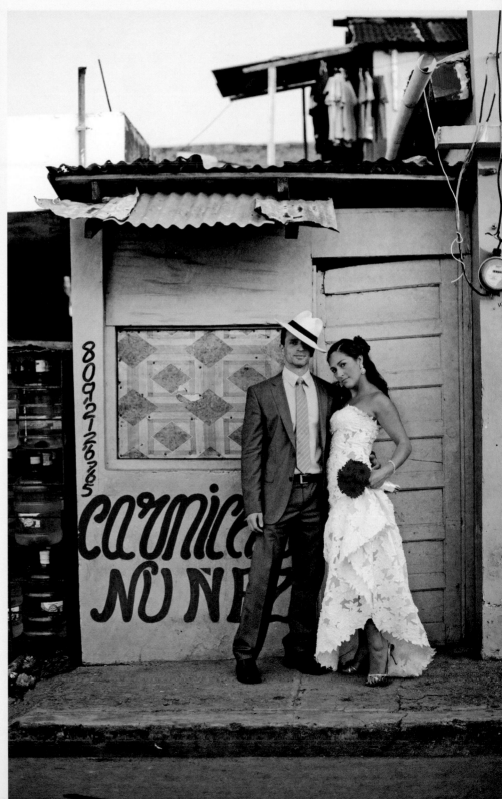

Color: Are there strong colors and will they enhance (or detract) from the image? I love bold colors and I try to use them whenever I see them.

Light: Is there a spot in the frame where there is amazing light? If I rotate my position and frame it differently, how will the light fall in my frame?

Environmental Elements: (This one is my favorite!) Are there any elements in the frame that give the photograph a sense of place? Is there anything that speaks of the environment in which the photograph was taken? Every couple that I have ever met has decided on their wedding location for a reason. They love the ocean or the mountains, they grew up on that particular lake, or it was the place where they first met. What is it about the location that makes it special, and how can you capture the heart of the location in your photograph?

STEP TWO: PLACEMENT OF THE COUPLE IN THE FRAME

Before you even give your couple the most basic directions regarding their body position or their interaction with one another, it is necessary to place them in the frame. You probably thought about this during step one, especially if you had leading lines or good light.

Where can you place the couple to maximize the effect of some of the elements you recognized in step one? Where can you place them in the frame so that they are a seamless part of the scene that adds to rather than detracts from your composition?

When I place my couple in the frame I am constantly aware of the strength of the composition and how other elements in the frame improve the image or detract from it. I scan the image to ensure that I am happy with the location of my couple before I ever ask them to get into position or interact with one another. If you are cropping anything on your subject, make sure that it is an intentional crop—watch for fingers/hands and toes/feet, since it can be easy to accidentally crop those if they are on the edge of the frame. Also watch the edges of the frame for distracting elements such as trash and clutter since those can detract from the image by pulling the eye away from the subject.

I try to use some compositional techniques to draw the viewer's attention to my subject. There are many that you can use to strengthen your image, but I find that I have my favorites. I use the rule of thirds, leading lines, negative space, light, foreground and background elements, and framing most in my images in order to highlight my couple. I don't often place my couple in the center of the frame—I only do so if I have some strong leading lines that pull the eye right into the center of the image, if I am photographing a group shot, or if I am trying to center my subjects within a frame of some sort, like a door, window, or another framing device). Most of the time I use a lot of negative space in my photographs in order to make a more dynamic composition and to give weight to the environment as well as to the couple.

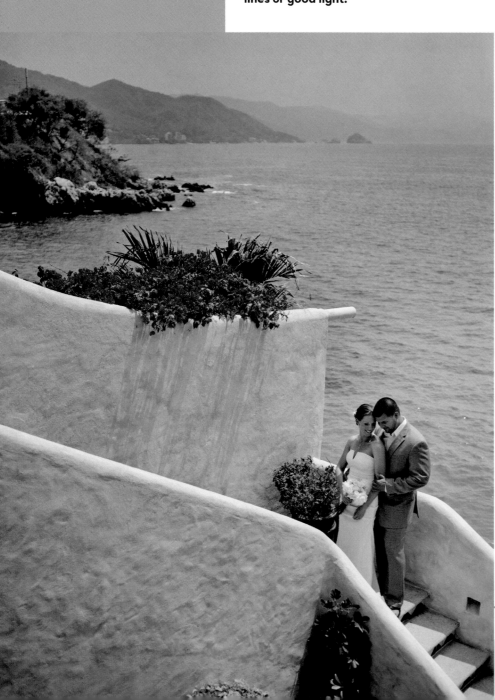

LEFT

Don't forget to lead the viewer's eye to the couple as they follow the lines of the image. In this case, I framed the couple between the wall and the edge of the photograph.

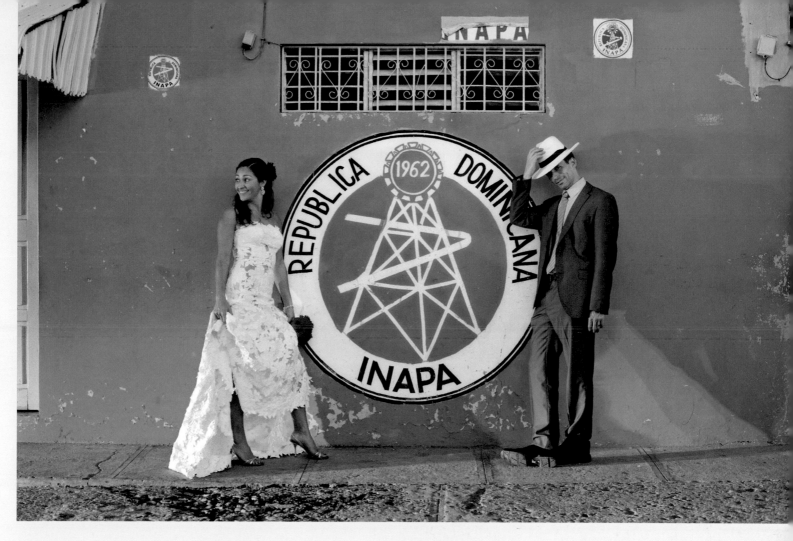

ABOVE
Sometimes where you place a couple and how you pose them will depend on the available light. I lit this couple with passing headlights so I staggered them in the frame.

BELOW LEFT
Leading lines can be a powerful compositional tool.

BELOW RIGHT
Balancing the couple with something else in the frame—such as the lighthouse used here—can help your composition.

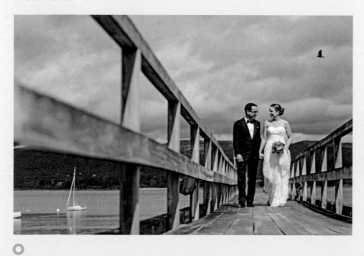

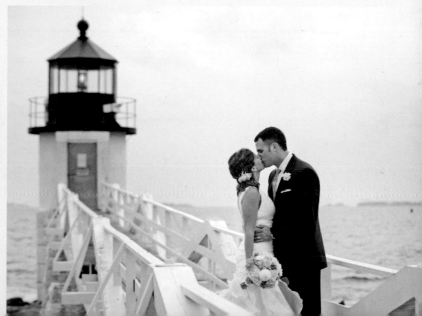

STEP THREE: POSITION

ABOVE
You don't always have to pose the couple so they are touching. Including some shots where they are separate in the frame can add interest to your images.

ABOVE RIGHT
Chest to chest is one of my favorite positions to photograph. Couples can kiss, laugh with each other, and interact naturally.

Now it's time to put the couple into the photograph. Before you tell them what you want them to do, you need to get them into the right spot and in the appropriate position relative to one another.

This step is all about their physical connection relative to the camera. There are several different positions that you can put them in. Obviously, your options will be limited by the choices you have made in step two and by their comfort level with you, with the camera, and with each other, but you should still have several options from this list to draw from in every environment and situation.

Chest to Chest: This position implies a certain level of intimacy and, depending on the couple, you may have to refine the pose a bit. The important thing to remember is that this is a "joined" position, so make sure that they are touching. If there is confusion, ask them to hug (and not the butt-out hug that you might give an acquaintance) and then refine the position from there.

Back to Chest: This position is a safe one to start with if you have clients that are having difficulty warming up to the camera. Either person can be in front; you do not necessarily need to put the shorter person in front as long as you choose an appropriate interaction from step four (see pages 36–37). Some people will automatically go into this pose if you say, "Cheesy prom photo!," but this position will become anything but that depending on the action/interaction that you end up choosing. If you keep your distance and let the pose naturally evolve, you may end up with a couple that has essentially curled around one another. If you keep asking them to get closer, you can make this position much more intimate.

BELOW
Most brides don't mind sitting, but if your bride is worried about her dress, you can fold up the top layer and have her sit on the inside of the dress so any dirt picked up won't be visible.

RIGHT
Standing next to each other is a very easy way to pose a couple, especially if they are nervous in front of the camera.

Sitting on or Between the Legs: There are two options with this position: the chest-to-chest version and the back-to-chest version. Obviously, the chest-to-chest version is more intimate and can take more coaxing and explanation. Be sure to refine this position if the legs of either person are too far apart, or if there is too much slouching (or possibly not enough slouching). This position works well on stairs.

Sitting Side by Side: Whether on chairs, on a wall, on stairs, or on the ground, this pose works well with almost all couples. You may have to refine their positions or give them more direction so that the couple is more connected to one another. They can appear very detached from one another depending on their

body language. You may want to correct their sitting positions and connect their hands in some way. You may also need to tell the groom to close his legs.

Standing Side by Side: This is another simple position, although you will want to be very aware of their body language and will want to refine the pose if they look too detached from one another.

In the Same Frame, Separated: There are many ways you could position them here. Perhaps you want to put one person in each door frame or hanging out of different windows. This can be a very fun pose that allows for a lot of creativity, although it does limit your action/ interaction options in step four.

One Sitting, One Standing: This can be a very sexy, fashion-forward pose depending on how you connect the couple and the action/interaction that you choose in step four.

Lying Down: Whether they are lying with their feet in the same direction or in opposite directions, this position can be a very intimate one to photograph.

STEP FOUR: ACTION & INTERACTION

Now that you have the couple in the frame in a basic position, it is time to set the mood of the photograph. Two photographs with couples in similar positions can take on two very different moods simply by tweaking the interaction within the photograph.

There are some actions and interactions which are more awkward for some clients, while others simply require a "warm-up" period before you start getting into the more intimate interactions. If I find that a client is embarrassed by any of the interactions, I either start slowly and give them a less intimate interaction or I turn my back under the pretense of changing a lens or a memory card or "checking something" for a minute or two to allow them to warm up to one another.

Looking at the Camera: Some couples will naturally lean away from each other for this type of portrait. Unless that is the look I am going for, I usually have to tweak this interaction and ask them to go cheek to cheek or to get closer to one another. "Snuggle in" is the term that I use. I don't create many portraits of them looking directly at the camera, but it's helpful to have a few.

Forehead to Forehead: This is an easy one because it can be performed in front of friends and family without embarrassment. The other nice thing about this interaction is that it gets them really close together, and they usually end up laughing because they are in so close. Most of the time I will tweak this pose by having them close their eyes.

Cuddle: There's a lot of mileage in this interaction. Whether it's the side cuddle, back cuddle, or front cuddle, it's really easy to ask them to just "cuddle." Occasionally I will ask them to close their eyes and rotate their heads toward me just a touch, so that I can actually see both of their faces without having them look at the camera or be straight on to the camera. I also try to connect them at as many points as I possibly can.

Kiss on the Forehead: This is a great one if you have a groom who is significantly taller than the bride. You will get a different feeling in the photograph by changing up what you ask the bride to do. If she closes her eyes, you will create a more intimate portrait. If she opens her eyes and looks straight at the camera while his eyes are closed, you will create something a bit bolder.

Kiss: My favorite, and one of the easiest to ask for. Don't be afraid to tweak the kiss by having them change their head positions.

BELOW RIGHT
Walking along a path or a beach will loosen couples up quickly. If you use a long lens, they may even forget that you're there!

BELOW
After you ask the couple to hug or kiss, don't forget to wait for the genuine interaction and emotion that will shine through.

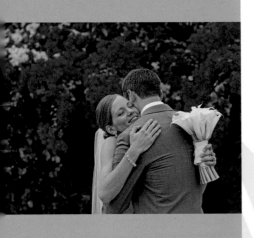

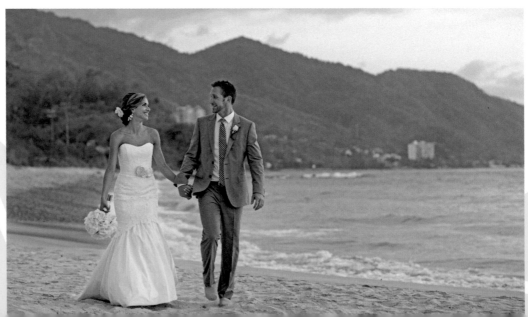

BELOW
Sometimes a prompt will result in laughter. This was one of my favorite images of the couple. I set it up, but it evolved into a natural interaction.

RIGHT
Keep shooting, even once you have "finished" the shoot. This moment happened as the couple was walking back to the car.

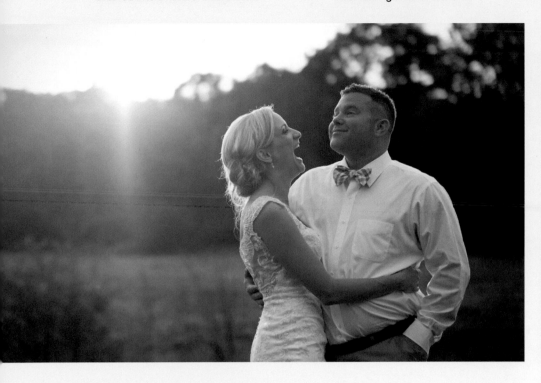

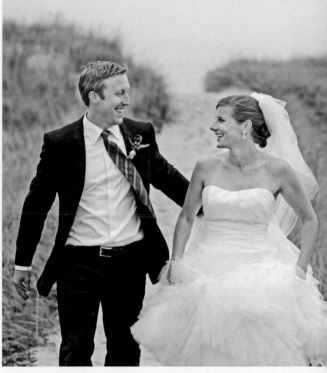

Remember, you want to avoid making it look like one person is eating the other person's face and you want to make sure that you aren't hiding one person.

Movement: Another easy one, shooting movement gives a lot of variety. You can photograph them moving away or toward you, fast or slow, walking, skipping, jumping, or running. I tell them that I don't want them to look at the camera, but that I would prefer that they talk to and look at one another, interacting with each other rather than with me.

Holding Hands: An easy stationary position to accomplish, you can tweak the mood by changing the distance they are from one another and whether they are looking at each other, looking at you, or in different directions. If you don't like the mood of the photograph you are taking, simply change their distance

from one another and where they are looking.

Head on Shoulder: Sometimes the side-cuddle ends up at this position. Occasionally though, it is easier just to ask for this position in the first place, especially if you have a couple that needs more direction.

One Looking at the Camera, One Not: This is another position that can be combined with some of the others, or it can stand just as well on its own. The mood of this shot will be affected by whether the person looking at the camera has a huge grin or is serious.

Detail Shot with the Couple as a Backdrop: This is another one of my favorites. When I refer to "detail," I don't necessarily mean the details from the wedding, although those are good too. Almost anything can be used as a detail—the rocks on the

beach, the flowers growing by the side of the road, or the antique car. Most of the time, my detail shots are taken with a very shallow depth of field so that the detail is in sharp focus and the couple is pleasantly out of focus.

STEP FIVE: CHOOSE YOUR PERSPECTIVE & SETTINGS

A big part of how the final image will look depends upon where you are positioned and what equipment and settings you choose to use. Are you going to take the photograph from below or from above? Will you shoot straight on or from the side? What lenses, lighting, and settings will you use to create the look you want?

The same position or interaction from a different perspective can yield a very different photograph. If you mix and match the positions and interactions/actions, you will come up with more than a hundred potential poses. If you add perspective to that as well, you can double the number of possible photographs. Look at the photographs on the next page, for example. That is the same location, the same body position and the same interaction. Those shots were photographed seconds apart, but because I changed my perspective and used a different lens, I have two very different photographs there.

When choosing a perspective, here are some things to think about:

1. Minimize the background. Get low and shoot up at your couple. You may find that your background is only what's in the sky (which may be some interesting cloud patterns).

2. Minimize everything except the couple. Crop in closely on the couple. It doesn't matter where they are at that point, since they are filling the frame.

3. Maximize the foreground. Get low on the ground and shoot straight at your couple. If you choose a shallow depth of field, you can either sharply emphasize the foreground and keep your couple out of focus or you can emphasize the color, shape, or texture of the foreground

BELOW RIGHT
I shot this image with a wide lens to emphasize the leading lines and frame the couple at the top of the stairs.

BELOW LEFT
I shot this with a longer lens to make the skyline of Boston seem bigger.

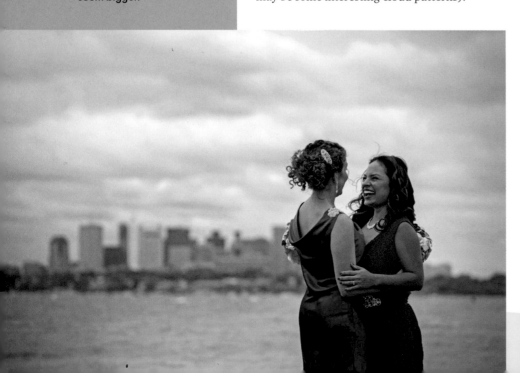

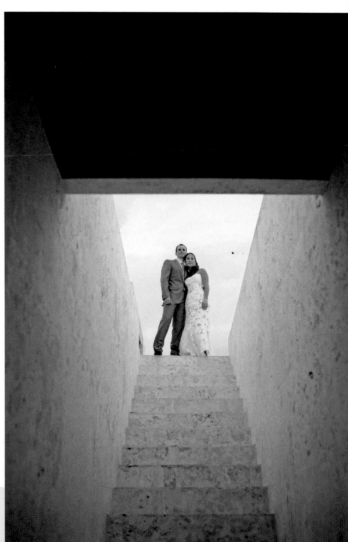

only, while keeping your couple in sharp focus. Or, of course, you can stop down and keep both in focus.

4. Emphasize the sky. Think about doing a silhouette and expose for the sky. Or, think about adding a bit of fill flash or video light to balance the proper sky exposure with the proper couple exposure. I rarely add any light to my scenes, but I know that there are people who use external light sources with fabulous results.

5. Include flare in your shot. Stop down to $f/13$ or beyond, choose a lens that flares easily, and dance around your couple until you get the amount of flare you want.

6. Shoot a detail with the couple in the background. Choose a shallow depth of field and fill your frame with as much of the detail as you can without pushing the couple out.

7. Emphasize the couple and their immediate surroundings. Position the couple on the ground and photograph them from above. You might also place flowers, leaves, ferns, etc. in the foreground and photograph the couple through them.

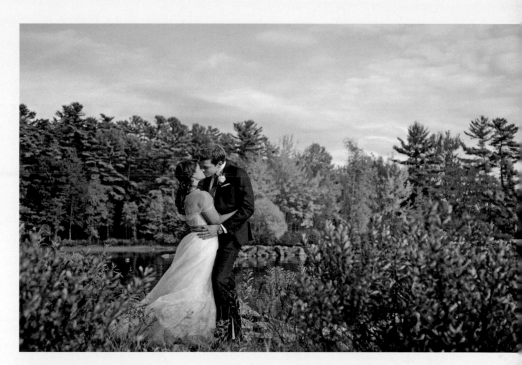

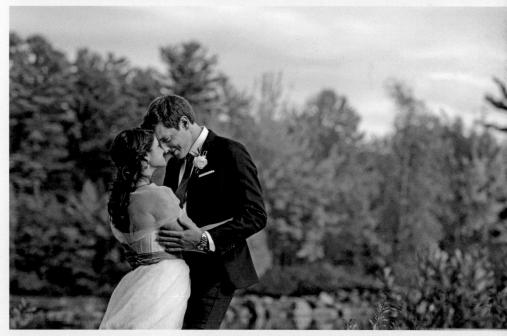

STEP SIX: TWEAK THE POSE & TAKE THE SHOT

The photograph is almost done. You have created your vision (step one), set the couple in the frame (step two), set their body positions (step three), directed their interaction (step four), and chosen your perspective, lens, and camera settings (step five). Now it's time to reevaluate the pose and tweak it if necessary.

So many people take a less than perfect shot with the excuse that they can "fix it in Photoshop later." Well, unfortunately for those people, while you can tweak your colors, elements, light, and contrast in post-processing, it is very difficult and often impossible to fix the pose after the shot has been taken. Check for things that look awkward in the frame. Does the groom have a hand just hanging by his side? Is the bride's shoulder tensed up? Is the bride slightly hidden by the groom and do you need to ask them to rotate so that you can see both of them better? Although I don't follow the traditional rules of portraiture, per se, this is where knowledge of them can come in handy.

1. Don't cut the hands off at the wrist or the feet off at the ankle. If you are in danger of cutting the couple off at the ankle, back up or ask them to back up, or get closer so that you can cut them off farther up the leg. Same with the hands; either back up or ask them to lift the hands and embrace the other person.

2. Create space between body parts to avoid the "blob" look to slim your couple. If they are too pressed together, ask for another interaction.

3. If it bends, break it. Other than when you are lying down, how often are you comfortably sitting or standing with all of your joints completely straight and locked? Almost never. It looks (and feels) awkward and is usually a sign of discomfort in your couples. Bend those elbows and unlock the knees. Bending the elbows, especially, will create space between body parts and have a slimming effect on the bride and groom.

4. Connect up stray body parts. You are standing at the airport, ready to say goodbye to your loved one and you lean in for a passionate and tearful kiss. How often do you lean in for that kiss with your butt out and your hands at your side? Not very often, as that doesn't say passion. Have your couples embrace each other, get as close as they can, connect their hands or put their hands around each other, and bring their legs in closer together. In short, they should be connecting on as many points as you can find.

5. Look for slouching and correct it. Sometimes you have to tell your couples to engage their

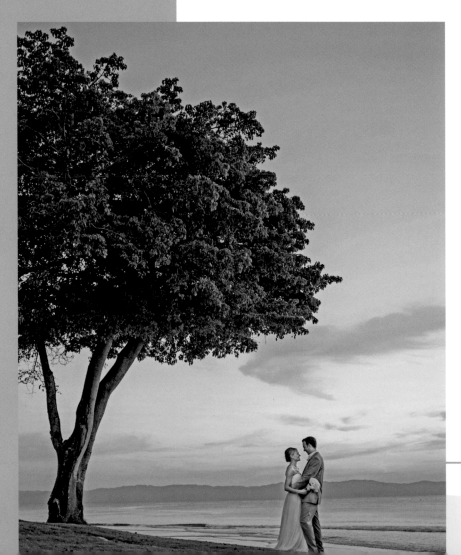

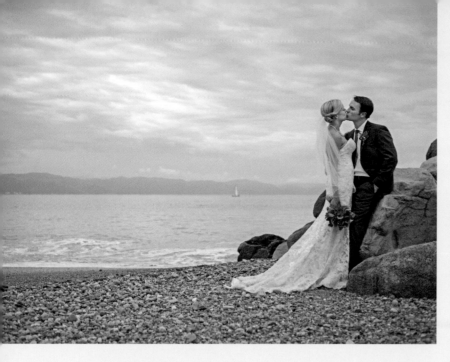

ABOVE

Try changing how the bride holds the flowers. She doesn't need to hold them up (above left) or even hold them at all (above right) in every shot.

RIGHT

Make sure you don't have too much space between the bride and groom. The right amount of space depends on the couple.

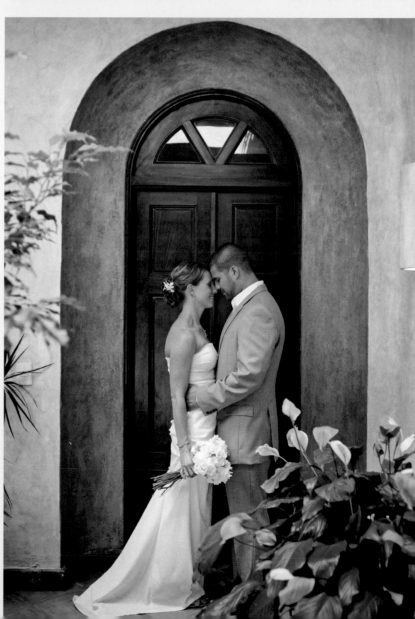

stomach muscles and create the illusion of good posture.

6. Look for body tension and correct it. The "claw hand," lifted shoulders, droopy heads, raised chins, butts out—if you see something tense, ask them to relax.

7. Give the hands something to do. This one is related to point 4. You need to connect up the body parts. Nothing says disinterest more than a hand laying limply at the side. Give that hand something to do—embrace something, stuff it in a pocket, hold a bouquet, put it on the groom's chest, or hold hands.

8. Avoid bouquet strain. A big bouquet can cause tension and ugliness in the forearm. Don't be afraid to ask the bride to put it down or have the groom hold it.

9. Watch the arms around the neck as this position will sometimes make them look big. Ask her to put her arms around his waist instead (under his arms).

STYLE & TECHNIQUES: DOCUMENTARY PHOTOGRAPHY

RIGHT
I'm quite short (5'4") so I'll jump up on a chair or couch or even hold the camera over my head to get shots like this.

Even though I really enjoy working with couples and creating environmental portraits, for the majority of the wedding day I am not interacting with them; rather, I am documenting their wedding day as it happens.

While I am not a true photojournalist (and there are amazing resources out there if you are looking to improve this aspect of your shooting, such as Foundation Workshops, the Mountain Workshops, and more), there are some techniques that I use to create a much stronger image.

First, I try to anticipate the action. Weddings, while unique, all follow the same basic formula. The players, traditions, timelines, and locations may all be different, but in most weddings the basic event is going to be the same. Anticipate reactions before they happen—the groom's reaction as the bride walks down the aisle,

mom's reaction to the maid of honor's speech to the bride, or the crazy dancing that erupts during the first dance set. Keep your eye on all of the major players, and look for action elsewhere as well.

Second, I try to compose a strong shot that encompasses more of the action. If I am photographing the groom's reaction to the best man's toast, then I want to frame the groom with the best man's outline. That way, it doesn't just look like a photograph of the groom laughing, it gives you the context as well since you can see that the best man is giving a speech. I try to look wider than the moment that I am looking to photograph. You may want to photograph the bride looking at herself in the mirror, but if you look wider, you may see her mother getting all emotional as she observes the bride looking at herself in the mirror. If you compose the moment carefully, you can include both of them in the frame.

ABOVE
Sometimes selfies can be fun
photographs to capture from
afar, too!

RIGHT
It's worth it to wait for a genuine
reaction and expression!

Preparation

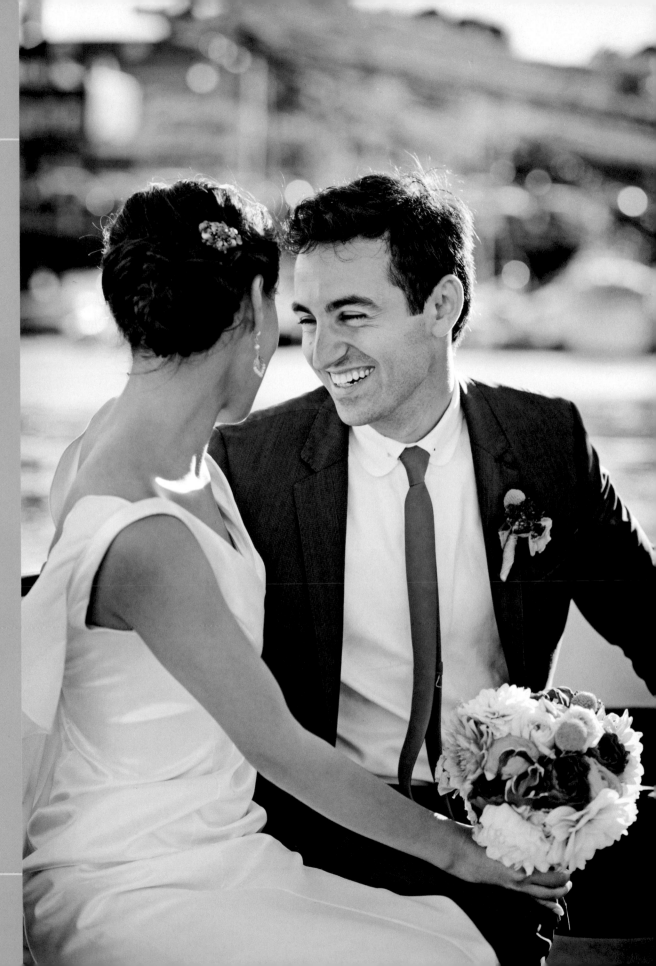

RIGHT
Try to get several shots of
each person looking at the
other throughout the day.
You'll capture a whole range
of emotions!

Third, I pay attention to my foreground and background. There may be something extremely interesting in the foreground that I will want to include to add a sense of place or humor to the photograph. Or perhaps there is something distracting in the background that will pull the viewer's eye away from the bride and groom. I try to pay attention to everything that is in my frame—or everything that *should* be in my frame—in order to create a stronger composition.

Finally, I try to pay attention to the "planned" events that do not appear on the timeline. On occasion, a surprise will be planned. If it is a surprise for the guests, then I'm always in on the secret. But if it is a surprise for the bride and groom (surprise fireworks, fire jugglers, a touching poem, a funny dance), then I will often be as surprised as the bride and groom if I'm not paying attention. Talk to the wedding planner, the moms, or the maid of honor to see if there are any other events planned; one of them is almost always in the know.

If you do deal with a surprise, you will have more chance of getting the shot if you have quick access to the equipment you might need at all times. I travel light, and often shoot with my 24mm, 35mm, 85mm, and fisheye lenses throughout the day. I carry those lenses with me at all times so, if something happens, I am always ready to get the perfect shot.

TOP RIGHT
I loved the emotion of this couple post-ceremony!

BOTTOM RIGHT
If the couple sneaks off for a private moment but you can still see them, throw on a long lens and capture a few frames.

LIGHTING A ROOM

Although I love shooting with available light, there are times when manipulating the light through creative use of additional light sources can improve a photograph, such as when taking a portrait with strong backlighting or photographing a dark reception.

Before I begin talking about the techniques I use to light a reception, though, it is important to review some of the basic principles of flash photography. First, it is essential that you know your flash sync speed. With most mirrorless cameras and DSLRs, that will fall somewhere between 1/160 and 1/250. Practically speaking, that means that my shutter speed cannot be faster than that if I want to make adequate use of my light (without going into high sync speed, which takes a lot more power out of my flash). Know what your camera supports, and you can work from there.

Remember that, when working with a flash, your shutter speed only controls your ambient light (it never controls your flash), while your aperture controls the amount of light from your flash that falls on your subject (the flash's

exposure) in addition to the ambient exposure. That means that if all else remains constant (your ISO and your flash power on Manual) and you want to increase the ambient (background) light in your photo so that you can see the candles on the table or the lanterns in the background, then you need to lower your shutter speed. If you are on 1/60, drop it to 1/30 to allow more ambient light into the photograph. If all else remains constant and you want to increase the intensity of the light that you are creating with the flash, you need to shoot with a wider aperture. If you are at $f/4$, try $f/3.2$ to increase the amount of artificial light on your subject. Of course, you can also increase or decrease the power of your flash or change your ISO, but if you are happy with those settings then it is important to remember that shutter speed controls ambient light, while aperture controls the flash's exposure.

Now, before you start worrying about blurry subjects on the dance floor at 1/30 of a second if you are letting more of the ambient light into the frame, keep in mind that flash will help you freeze the motion even if you are dragging the shutter (working at a slower shutter speed). There's a science behind this, but basically, flash can help you stop motion if your flash is the main source of light on your subject in the frame and it is more powerful than your ambient light by several stops. Put another way, if you turn your flash off and your subject is dark, perhaps only partially lit (and not well at that, with no highlights on the skin or clothing) by the ambient light, then you will be able to stop motion with your flash.

When I am working with flash I am always in Manual mode on my camera and Manual

RIGHT

Even rooms with a lot of ambient light can use additional lighting from time to time to create directional light on your subjects.

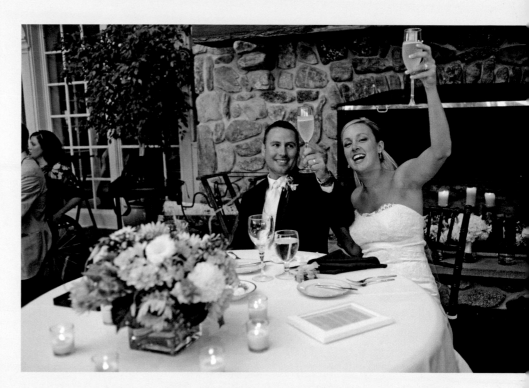

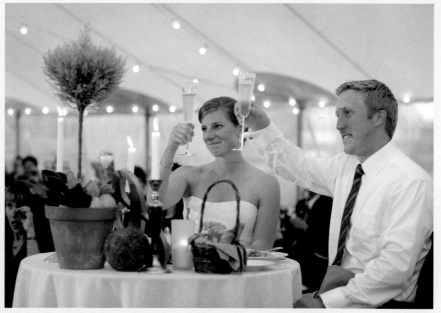

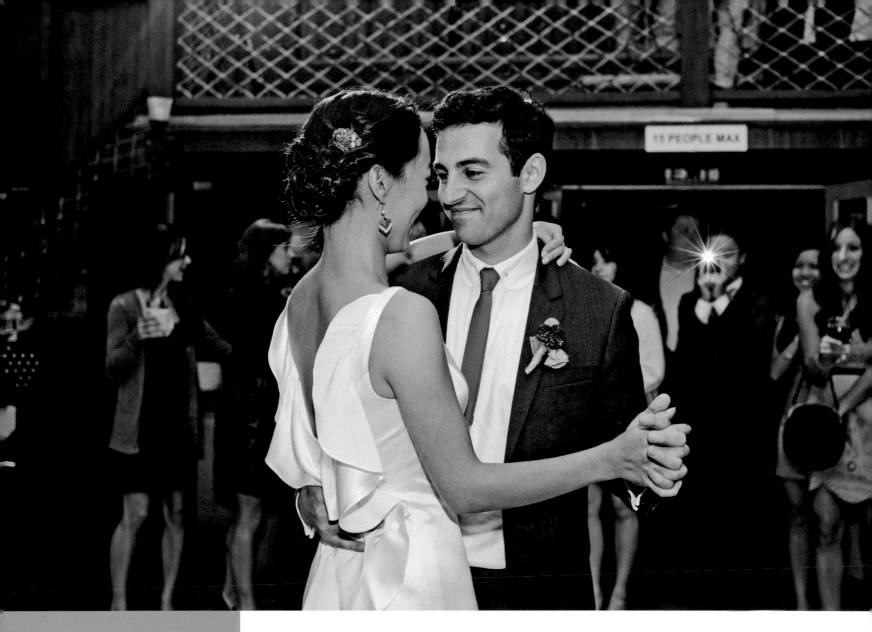

ABOVE

When you are in a dark scene and have no ambient light to draw on, adding a flash behind your subject (in this case, on the balcony) can add some beautiful rim lighting to your subjects.

mode on my flash. When I enter a room and I plan on using my flash, the first thing I do is take an ambient light reading. I dial my ISO up as high as is needed. I often shoot at 3200 and 6400 with my cameras. If I have a good exposure in-camera, the digital noise is minimal. If the ambient light is not pretty (bad overhead tungsten lights, for example) or not important, then I won't worry about preserving my ambient light. Most of the time, though, the couple has spent quite a bit of time thinking about the ambience at the reception, and I'll want to preserve those lanterns overhead or the uplighting on the draped walls.

When working at a reception, I generally use off-camera flash. It gives me complete control of the light. However, if you aren't ready to consider off-camera light, you may find that one flash on-camera will be sufficient, especially if you are working in a room with light-colored walls or a tent. You will be amazed at the power and beauty of a single on-camera flash that is bounced off of a wall. I rarely bounce overhead; rather, I'll try to find a bounce surface on the sides of the room so that I can create flattering short or broad light on my subjects and keep the image from looking flashy. If you are working with one on-camera flash, a good dose of

BELOW
I love directional light so I try to bring
light in at an angle to the subjects.

ambient light in the image may be essential to help you keep the room behind your subject from looking like a black hole (although the directional bounce will help with that as well).

Remember, you can change how dramatic or subtle your light is by changing the angle of the bounce or the power of the flash. You can also play with different bounce surfaces to achieve different effects. Bounce light off of walls, ceilings, and floors to produce beautifully lit photographs that produce little or no flash shadows. You will, however, need to be aware of the color of the surface you want to bounce your light off, as this can affect the color of the light that bounces back on your subject. If you are working with neutral bounce surfaces, you won't have any issues with colorcasts affecting your subject. If you are bouncing off colorful walls, though, you'll want to take a custom white balance (I use my ExpoDisc for this) so that you don't end up with subjects who have sickly looking skin tones.

If there are limited options for bouncing, don't forget that you can use a portable bounce surface like a reflector. That said, while this is an easy solution for portraits, it's not practical for lighting an action-packed room. This is the time when off-camera flash really shines. If I am working with off-camera flash, I'll reach for my Profoto lights first (my B1 or B2). They are powerful enough to light any room and I don't need to worry about cords or the recycle time. If I'm working with speedlights, then I'll grab my Cactus V6 trigger/receiver and set up my speedlights on light stands. How many flashes I use depends on the size of the room that I'm working with, but I typically use two or three flashes off-camera and one flash on-camera (bounced) for fill. Remember to keep your shutter speed under your sync speed or your flash might not match up with your shutter, leaving you with a black frame or a black bar across your images.

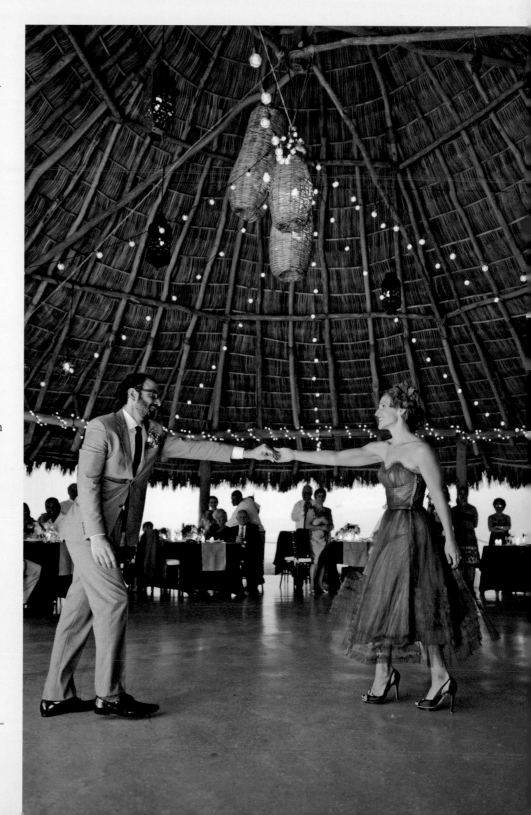

CREATING LIGHT: REFLECTORS & OFF-CAMERA FLASH

Occasionally, I'll have a beautiful scene to work with, but the natural light just isn't cooperating. Perhaps the wedding is early in the day and we are dealing with beautiful blue skies paired with harsh midday sun. Or perhaps the wedding is on an overcast day and I need to add light to keep my subjects from having dark shadows under their eyes.

I may find that I love a particular background, but that I just don't have enough light to expose properly for the couple and my background at the same time. In these situations, I'll create light to bridge the gap between the background and my subjects.

Some situations call for just a bit of light. This is the perfect time to pull out my reflector. I use one from Profoto that has white on one side and "sunsilver" on the other (it's a mixture of gold and silver). I like this reflector because, first and foremost, it has handles. That means I can shoot

and hold the reflector at the same time if I need to. I also like this particular model because the sunsilver is quite unique and provides a beautiful light that replicates the look of the sun. I can use the sunsilver side if I'm trying to recreate the look of a beam of light falling on the couple, but I can easily switch over to the white side if I want a softer look that allows me to simply fill in some of the shadows on their faces.

Occasionally, though, the light won't be in the right place to allow me to use the reflector easily. Perhaps it is hidden behind a building or a stand of trees and I can't get a solid bounce. Or I may be working on a day where there isn't enough ambient light (a darker overcast day) to give me a good bounce. If that's the case, then I'll pull out my off-camera flash. Setting up my image is typically a three step process once I put on my light:

1. I expose for the background (my flash is off at this point). In other words, I choose an exposure that captures the scene beautifully. This may mean that I underexpose the ambient light in order to deepen a sunset, or it might mean that I overexpose the ambient light in order to bring beautiful blue tones back into a dark sky. Whatever I'm trying to capture in the background, I choose settings to allow me to get a nice exposure.

2. Once I have those settings dialed in, I'll turn my light on. I'll already have my light set up on my light stand with a modifier (typically my Profoto shoot-through/translucent umbrella, although occasionally I'll use the Profoto Octa Softbox) if I'm photographing the wedding by myself, or I'll have my assistant holding the light on a monopod. I'll take a shot with my light on and make sure that it illuminates the couple while balancing well with the background.

3. This final step is all about tweaking the image. If I have too much or too little flash, I'll turn the power of the flash up or down via my trigger. If I have too much or too little ambient light, I'll use

BELOW
You don't always have to put the flash in front of your subjects. Don't forget to experiment with other angles as well. The flash was behind the couple in this image.

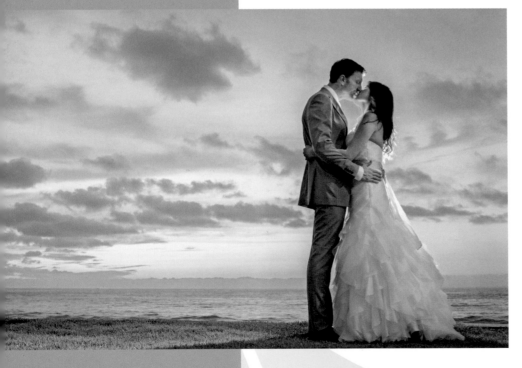

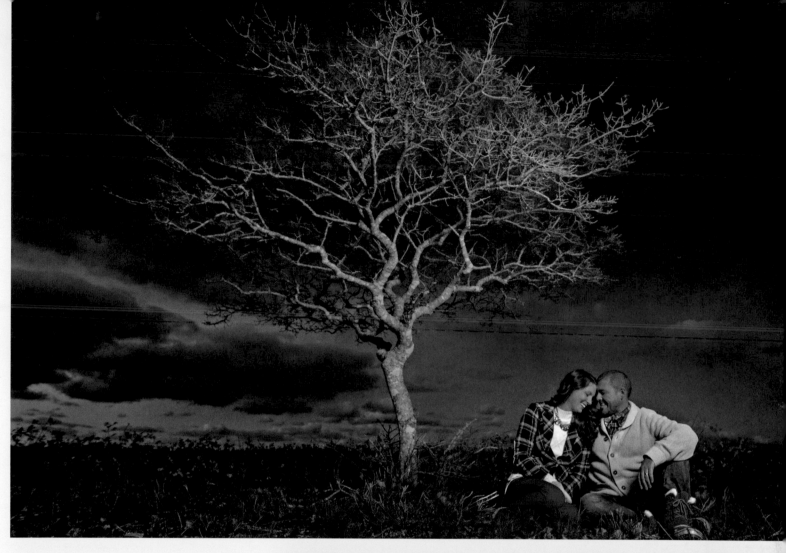

my shutter speed to adjust the ambient light (since shutter speed won't affect my flash as long as I stay under sync speed). If my composition is off, I'll recompose the image in order to create a more pleasing frame.

Once I have the light perfectly positioned and balanced, I'll generally snap a few different images. I aim to get a few usable shots out of the light setup, so I'll either try one or two body positions or I'll use one pose coupled with another action/interaction to create a different image.

ABOVE & RIGHT
Sometimes you just need to add light to make an image work. You can see the scene before I added the flash (bottom). I then used my Profoto D2 to add light to the couple, the grass, and the tree.

CAPTURING THE SUNSET: SILHOUETTES & FILL FLASH

A sunset can be a beautiful thing to photograph, and if there is a gorgeous sunset during your wedding or engagement session, you can bet that your couple will want it incorporated into their photographic coverage.

There are two different ways I capture an amazing sunset or an incredible sky at dusk— either with a silhouette or with an image that has a touch of fill flash.

The silhouette is one of my favorite images to take, and it is easy if you follow a few basic steps. First, remember that the greater the percentage of the photograph that the sky occupies, the more dramatic your silhouette photo will be. When I am setting up my silhouette photograph, I try to elevate my couple to put their head "in the clouds," so to speak. This can be accomplished by having your couple stand on a hill or by lowering yourself

to the ground. If you are on a beach or in an open field, this is an easy task. If you are in a city or a forest, it's going to be a tougher assignment, so you may want to scout the area ahead of time to look for a potential location. Pay attention to the body position of your couple. If they are too close and intertwined, they may look like one big blob in the photograph. Make sure they have space between them and that their individual shapes are clearly defined. Finally, you want to expose the image for the sky. If you slightly underexpose the image, it will bring out the colors in the sky.

If you've chosen settings for your silhouette photograph that have your shutter speed under your sync speed, then you will be able to move directly from a silhouette shot to a beautifully lit sunset photograph with the same settings. If the sky looks good but the couple is dark, all you need to do is add light to illuminate the couple. This can be accomplished in a number of ways,

BELOW
You can capture a beautiful silhouette by exposing for your sky and letting the subjects go dark.

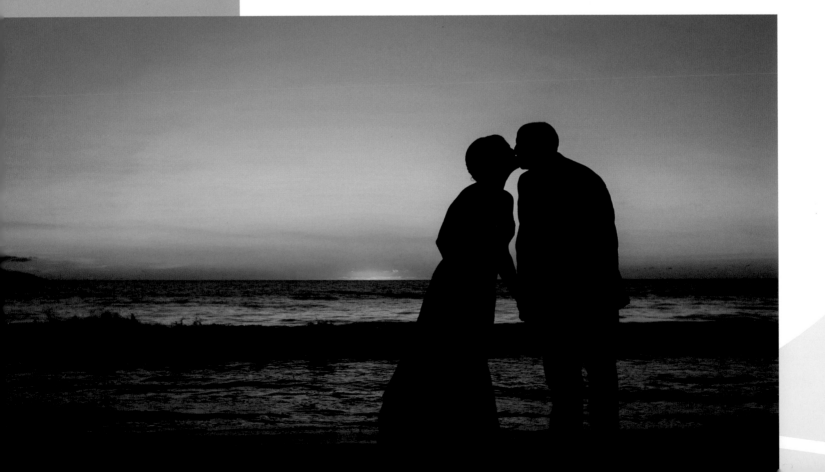

"The greater the percentage of the photograph that the sky occupies, the more dramatic your silhouette photo will be"

but the most versatile way is to use your off-camera flash. I'll simply turn my flash on and add a modifier. My favorite modifiers to use during a sunset are a simple translucent shoot-through umbrella from Profoto (this is also very portable and very easy to set up in a matter of seconds) and a Profoto Octa Softbox with a grid. While the former allows me to spread the light, the latter allows me to closely control the spill of the light (this is useful if you have other things in the frame that you don't want to light).

If you don't use your flash off-camera, then you still have options. You can bounce your on-camera flash off something near you (a building, a reflector, or even a person standing nearby) to light your couple with soft, more directional light than on-camera flash will provide. If there is a videographer present (or if you have a video or continuous light) and her video light has enough power to illuminate the couple while properly exposing the sky, then you can ask to use that! (Often they'll have it out because they are capturing the same thing.)

In a pinch, you can also use straight on-camera flash. The light this produces will be flat, but if you closely control the output of the flash, you can create a nice sunset image by balancing on-camera flash with the ambient light. I generally use my flash in Manual mode, and this is a situation where manual flash will be very helpful for you since TTL can be fooled by the bright background.

RIGHT
Sometimes you just need a touch of light to create an image. The image on the upper left shows that the couple is a little dark when I exposed for the sky. I added light through my Profoto translucent umbrella (lower left), and then tweaked the shot by changing my perspective and getting low.

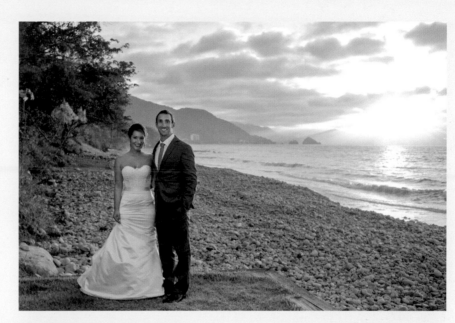

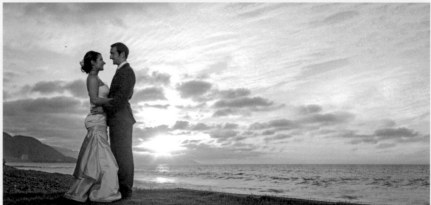

INCLEMENT WEATHER: USING LIGHT & COVER

One of the questions that I am asked more than any other is, "What if it rains or snows?" If the weather report is predicting inclement weather, then I'll be sure to have a conversation with the couple prior to the wedding day. I'll suggest umbrellas, cute rain boots, matching scarves—anything that is appropriate for the weather we are expecting.

The reality is that we can still capture beautiful photographs of the bride and groom in less-than-perfect weather. Some of my favorite photographs were taken on rainy days!

If the weather turns suddenly, then I'll chat with the bride and groom on the day of the wedding. If the outdoor location is beautiful, I always suggest we go outside. However, I'm careful not to push it. The wedding day is not about me, and even if I think that we could capture a beautiful image in the rain or the snow, I'm never going to push the bride and groom to do something that they don't want to do. If they aren't sure what we can capture in the rain/snow/wind, I have a few photographs on my phone that I can show them. As I said, some of my favorite images were taken in inclement weather!

If it is raining or snowing, one of my favorite shots to take is an off-camera flash image where I place the flash behind the couple (make sure that you take measures to protect your equipment from the rain or snow). If you place the flash behind the couple (or subject), you can illuminate all of the rain or snow in the air, making it an important piece of the composition. Occasionally, I'll use one light behind the subjects then add a reflector in front to bounce some of the light back onto them. This image is always a crowd pleaser, because it celebrates the bad weather and gives the couple something unique.

BELOW
Bad weather? Grab an umbrella and go! Most couples are happy to take photographs outside in the rain.

ABOVE

I love to put a flash behind the subjects and stop the motion of the raindrops, making them glow around the couple. If you want to light the couple as well, use a reflector (I used the Profoto sunsilver here) to bounce light back onto the couple's faces.

BELOW LEFT

Even if the couple doesn't opt for formal photographs outside, you can capture them on the way to or from the venue. Grab a long lens and wait for the right moment.

BELOW RIGHT

A rainy day can make for a beautiful photograph even if your subject is standing under cover.

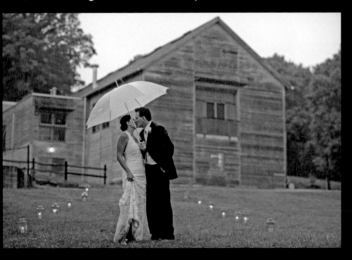

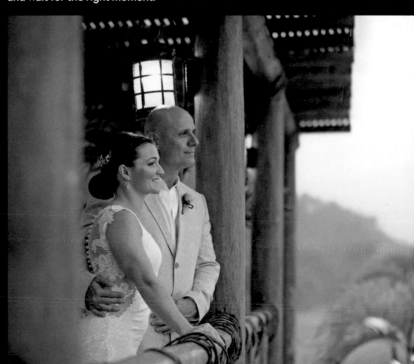

CAPTURING FIREWORKS

I love fireworks! I always have, ever since I was a child. So I find it incredibly fortuitous that several of the weddings I photograph each year involve pyrotechnics. I guess my clients love fireworks just as much as I do, and it's just another reason that I absolutely adore the couples I work with.

One of the questions I am often asked is how to photograph fireworks when you are trying to include the couple in the frame. There are certainly a lot of ways you can capture great photographs of fireworks at a wedding, but here is the approach that I generally take.

First, it is important to understand that fireworks displays vary in how they are staged. When you find out that there are going to be fireworks at your wedding, there are some very important questions that you need to ask. Where are they lighting the fireworks and in what direction are they planning to shoot them? How long will the show last, or (even better) how many are they planning to light? Where is the closest spot that the couple can stand? Many states have very strict laws governing the use of fireworks and there will be a clear line that may not be crossed legally.

Next, you will need to make some observations. Which way is the wind blowing and how hard? If it is really windy, this may affect the accuracy of the placement. In that case, you may need to choose a spot for the couple that gives you more flexibility to move and frame them (or you may need to select a different lens). How much moisture is in the air? If it is humid or foggy, the light will bounce off the moisture in the air creating an interesting effect and giving you more available light to play with. How close will the couple be standing to a light source? If they are near a building, lamp, or a video light, it will affect your exposure and how you balance the light on the couple with the light from the fireworks. Finally, I prepare the couple for the display. I tell them that I will be shooting at a low shutter speed and I ask them to remain still (hugging each other, of course) for at least a few moments during the display.

Most of the time, my favorite fireworks photographs include little additional lighting. I love shooting fireworks with the light from the fireworks themselves and from any additional light sources that are close to the couple (the venue, for example). However, because of the unpredictable nature of a fireworks show, I always have my lighting set up ready to go. If the couple will be standing apart from the crowd (I prefer to elevate them if at all possible (which allows me to get down below them and shoot up if the fireworks are high in the sky), then I'll set up two off-camera flashes. I'll put one on either side of the couple—one slightly in front of them to illuminate their faces if they are turned toward me and the other slightly behind them to produce nice rim light if I'm not getting enough separation between my couple and the black sky behind. I also have a flash with me for on-camera fill or in case of emergency (if one of the other lights malfunctions, for example). I rarely use all three lights, but private fireworks displays are often brief, and once they start I won't have the opportunity to adjust the lights and troubleshoot, so I want to give myself the best chance to capture the images that I need.

My trigger (either my Profoto trigger or my Cactus V6 trigger) gives me the ability to turn each light on and off directly from my camera,

BELOW
Some of my favorite moments happen during a fireworks show!

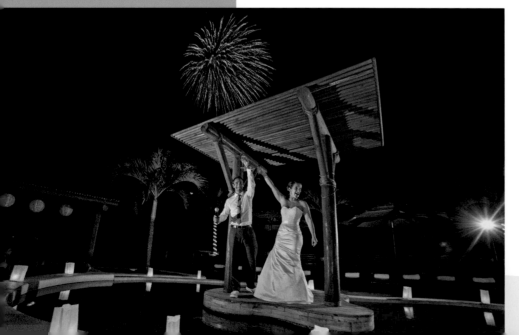

so if I decide that I have enough light coming from the fireworks, I can turn off the one behind providing my rim light. If I want to completely disable my lights and just shoot with natural light, I can do that as well. That's a decision that I'll need to make very quickly, so I'll start out with both off-camera flashes firing and shoot a couple of frames with the very first bombs, then quickly evaluate. The only time I deviate from this is when the couple is standing right next to a bounce surface (for example, if they step out of a building or tent to see the show but are still standing fairly close to it). In that case, I may set up my lights and have them ready to go, but start off the show by simply bouncing an on-camera flash to light my subject. That will give me nice, soft, directional light on the couple.

I typically shoot with a very wide-angle lens in order to capture the show. I like to be somewhere in the in the 8–24mm range, depending on the venue. If I suspect that I'm going to have trouble focusing on the couple in the foreground due to a lack of ambient light, then I may switch from autofocus to manual focus. In terms of settings, it really depends on how much light the venue is throwing, how dark the night is, and how many bombs will be set off at once. I'll generally start at ISO 1600–3200, f/2.8–4 (I'm shooting with a wide-angle lens so I'll have a deep depth of field), and a shutter speed of 1/30–1/60 so that I can capture a bit of the movement of the fireworks in the sky to make them look bigger than they are. I make sure that I'll have enough light at my chosen ISO and aperture to light my couple with my flash, and then I use my shutter speed (which doesn't affect the amount of flash) to dial in more or less ambient light on the fly. If I need to turn my flashes up or down (since I always fire them in Manual mode, never in TTL), then I'll do that from my remote as well.

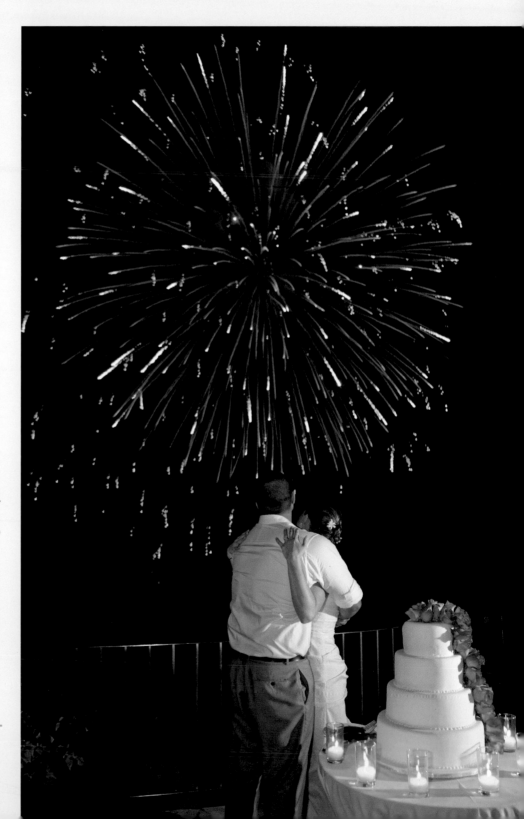

CAPTURING THE VENUE AT NIGHT

The venue, whether it is a hotel, a tent, a restaurant, or the great outdoors, will look very different at night. If the venue is blazing with light in contrast against the dark sky, it is a photograph that the bride and groom will love and one that the venue will love too, as it is a special take on the standard venue shot.

First, you need to choose the best time to take the photograph. You can take it right after sunset if you would like to catch some colors in the sky, but it may be too bright to capture much of the ambient light. If you wait about 20 minutes longer, you can capture the dark sky with a bluish hue and also pick up the glow of the ambient light. Generally, I want to take the photograph before it is completely pitch black, but 20–30 minutes after sunset. Depending on where you are and the geography around you, the timing will vary.

Next, be prepared for some really low shutter speeds. If I am not rushed, I am comfortable holding my camera at 1/8 or even 1/4 of a second. However, these photographs may need a shutter speed of a second or even longer, depending on how dark it is and how much ambient light spilling out of the venue you have to work with. I don't carry a tripod with me, but if that is something you like in your kit, this is the time to put it to good use. If you don't have a tripod, anything can be used to stabilize the camera. I will grab a chair, table or even a car and place my camera on that to hold it steady.

I like to shoot night shots in Manual, but it can be done in Aperture-Priority mode if you crank up your exposure compensation. You will want to overexpose the photograph to bring out the blue in the darkening skies. I generally meter the scene and then set my camera 1/3–1 full stop above that reading. I like to shoot the scene anywhere between 800–1600 ISO.

RIGHT
This tent looked beautiful at night with a warm glow against the deep blue night sky. I loved capturing the surrounding scene, as well. The moonlight on the ocean behind the tent was a bonus!

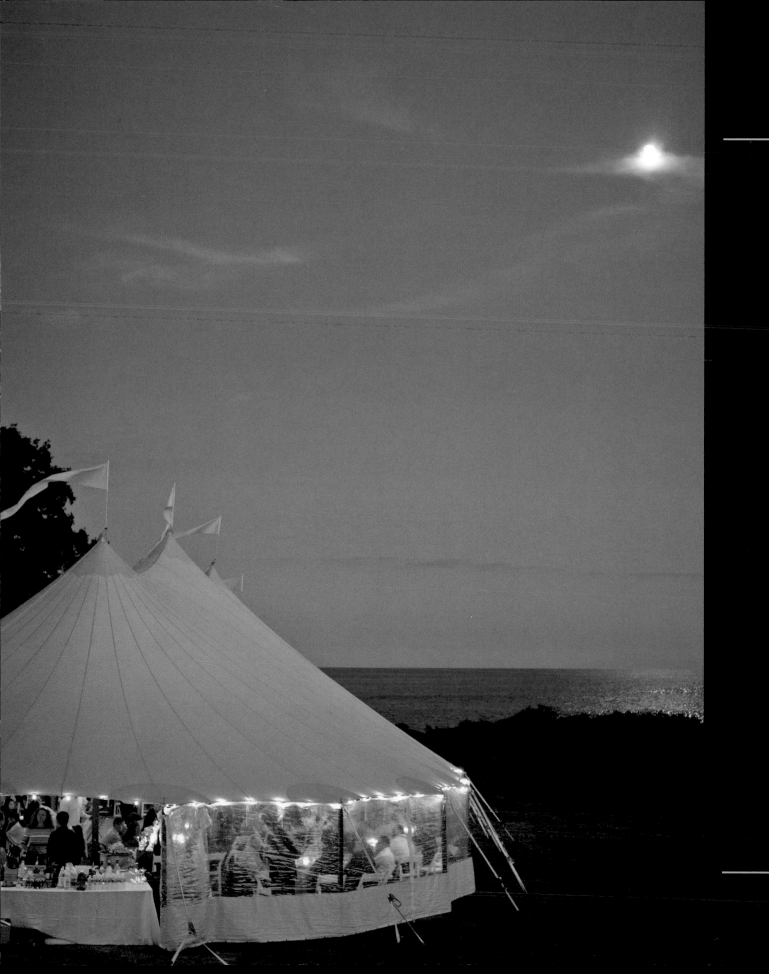

ENGAGEMENT SESSIONS

I really enjoy engagement photographs because they give me a chance to get to know the couple and have fun with them.

It is also an opportunity for a photographic trial run, and it gives me valuable information about the couple. Does the bride fidget with her hands? Does the groom have a lazy eye? Are they blinkers? Do they cuddle up together naturally, or does it take a bit of coaxing? Are they comfortable in front of the camera, or are they nervous?

The engagement session also gives the couple a chance to get to know me and my style. Up until this point, they have seen my images, but they don't know how those images were captured. They don't know what to expect, and sometimes they are nervous about having their picture taken. The engagement session gives them a chance to have fun with me and get excited about their photographs on the wedding day. It also gives us an opportunity to create beautiful images in an environment that is not stressful. There are no time constraints, there are no guests to worry about, and emotions are not running high.

My engagement sessions usually last at least an hour. They may run over if we are traveling to a few locations or if we really get in the groove and are having fun. I tell the couple how long

RIGHT
I photographed this couple at the Philharmonie in Luxembourg before their wedding.

engagement sessions usually last so that we are not pressed for time, and because I like to do on-location shoots using available light, I try to schedule my sessions for late afternoon, about two hours before sunset. That way, the light is becoming better toward the end of the session as they are warming up to each other and to me.

I also give my couples advice on what to wear or bring to the session. While I don't give them specifics, I do make sure that I give them some guidance on this point. I like my couples to be relaxed and wearing clothes that they don't have to constantly tug at and readjust, which can really help them loosen up and lose the stiff look in photographs. I also want them to be able to cut loose and enjoy the session, so I encourage them to wear clothes that they are happy to get wet or dirty. If they are more adventurous, then I may suggest that they bring props too.

I always start out with a few standard poses. (Refer back to the environmental posing guide at the beginning of this chapter for more details on how I pose my couples and compose my shots.) The session usually evolves, though, as we get to know each other and start having fun, and partway through I find that I need to give fewer instructions as the couple relax and become more spontaneous.

The engagement session also gives you a wonderful opportunity to create some beautiful products for the wedding. If you photograph the session early enough, you can use the images to create visually appealing, customized save-the-date cards and wedding invitations. You can also use the images to create an engagement book for the couple that can double as a sign-in or guest book at the wedding. Some couples even integrate the engagement photographs into their wedding favors or their table cards. The session can really provide them with a great opportunity to individualize their wedding.

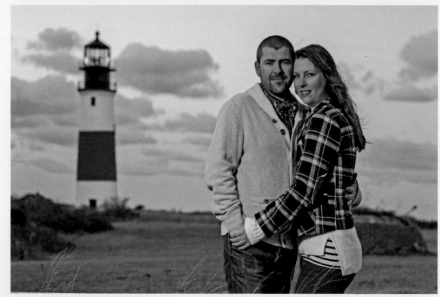

TOP
This couple wanted photos taken on a mountain in New Hampshire to contrast with their Caribbean wedding.

BOTTOM
An oft-photographed lighthouse and a beautiful sky in Nantucket provided the background for this couple.

SESSION 1: CATE & SARO

Cate and Saro live in Brooklyn, New York, and they wanted engagement photographs that would reflect their personalities and where they were at that time in their lives. Their wedding was in Mexico, so it was important that the engagement session reflect their life in New York.

Cate wanted a vintage-themed session with a lot of fun props, so I encouraged her to bring as much as she wanted to the shoot. From the hats to the gloves, the outfits that she and Saro chose really reflected the look that they wanted. They also brought a number of props, including bubble guns, water balloons, and chalk.

At the beginning of the session, I tried to incorporate architectural details that were unique to their neighborhood as well as some of the New York cityscapes. As we relaxed into the session and began to have fun, we brought out some of the props. I set up Cate and Saro with New York City as a backdrop, and they had a water balloon and bubble fight, which made for some fun photographs.

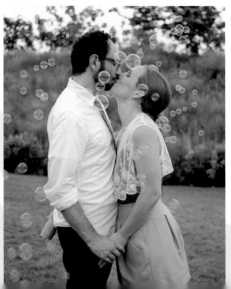

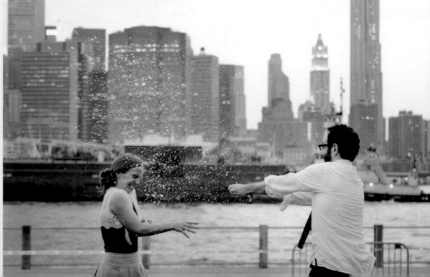

SESSION 2: ASHLEY & JOHN

Although Ashley and John were planning a coastal wedding, Park City, Utah, was a very special place to both of them so it made sense to hold a destination engagement session there.

Plus, a Utah engagement session would give them images that were significantly different from the New England wedding that they were planning for the following year.

I liked having the opportunity to photograph them in a more casual environment, and in fact, enjoyed this session so much that I returned to Park City after the wedding to photograph them again after they had a baby.

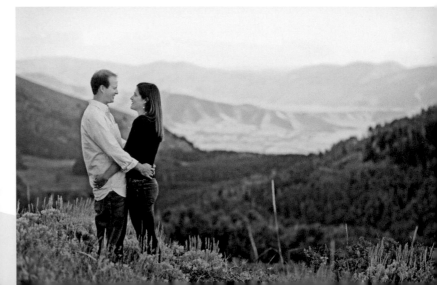

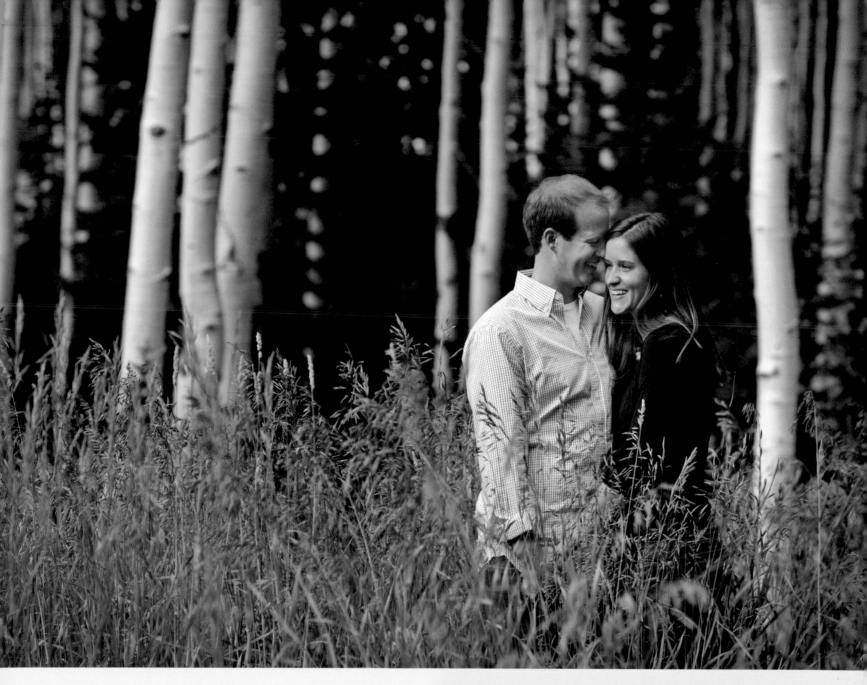

SESSION 2: ASHLEY & JOHN

Preparation

SESSION 3: DINAH MARIA & TOM

Dinah Maria and Tom planned a Puerto Vallarta wedding in Mexico, and they wanted to do an engagement session there before their wedding as well.

They were looking for just the right combination of the gorgeous coastline and the colorful town in their images, and since they had to plans for a "trash-the-dress" session, they wanted to get wet during their engagement session too. I like to start engagement sessions an hour before sunset, but since we needed to go from the town to the beach I wanted to start earlier. It was really bright, so we chose areas in town that were shaded by other buildings. Still, the light was very harsh so I chose a lot of nuzzling poses so that the couple could either focus on one another or close their eyes. When we arrived at the beach the sun had dropped considerably and the light was perfect for a beach session. I gradually moved them into the water, and when we ended with the sunset photograph; I shot it as a silhouette so that you couldn't tell that they had wet hair and clothing.

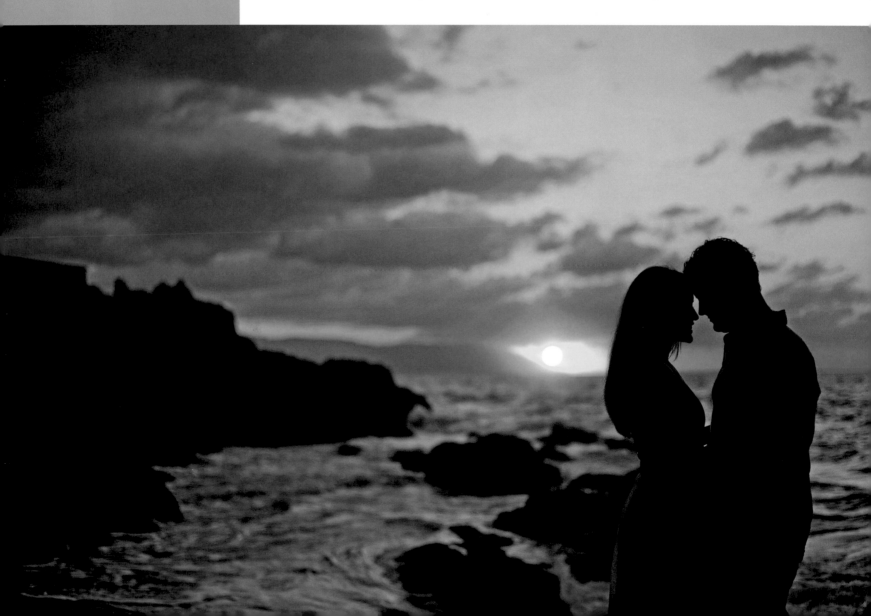

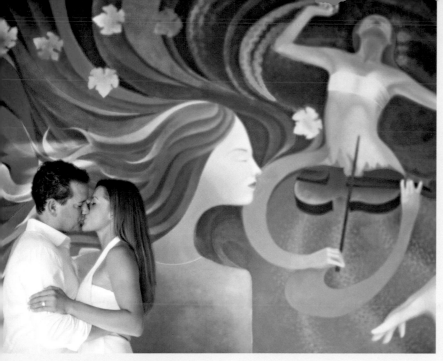

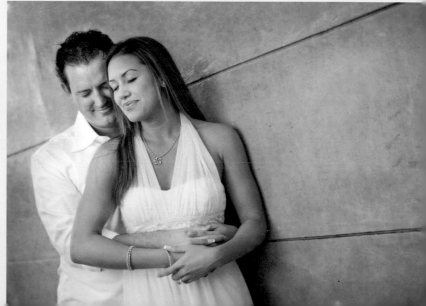

SESSION 4: VICTORIA & MARC

Victoria and Marc live outside of Acadia National Park in Maine, so it seemed only fitting to use the park as a backdrop for their engagement photographs.

We planned an engagement session that would allow us to visit some of the more beautiful spots in the park as well as spend some time in the

places that held meaning for the two of them as a couple. Since Victoria is from England, it also gave her an opportunity to give her friends and family in the UK a preview of the places they would see when they came to her wedding.

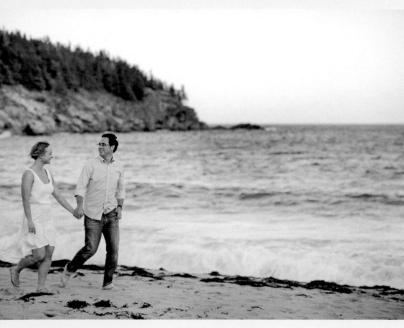
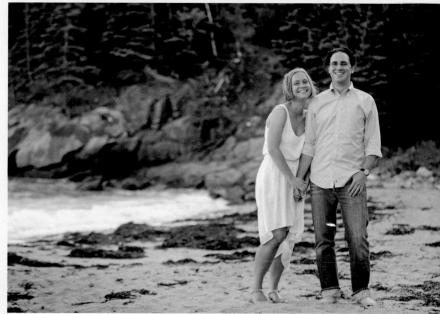
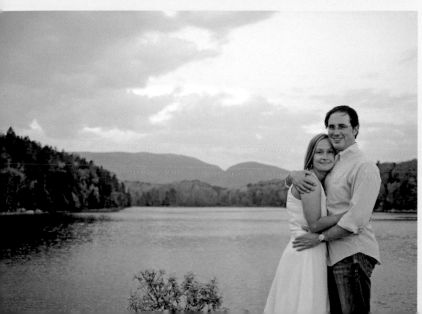
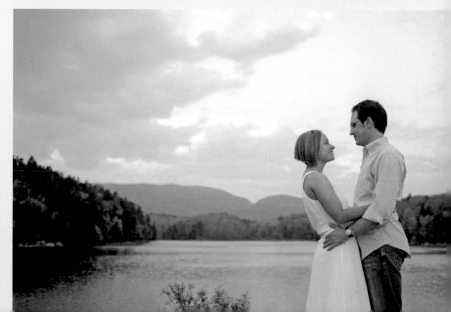

SESSION 5: DIDI & BRANDON

Didi and Brandon were separated by an ocean throughout their engagement, so we had to choose a spot they could both get to.

Luckily, Didi's time back in the States coincided with cherry blossom season in Washington D.C., so that was an ideal spot for their engagement session. Shooting on government property requires a permit, so we chose to photograph the monuments from afar to keep things more casual as well as keep the crowds enjoying the cherry blossoms out of our photographs.

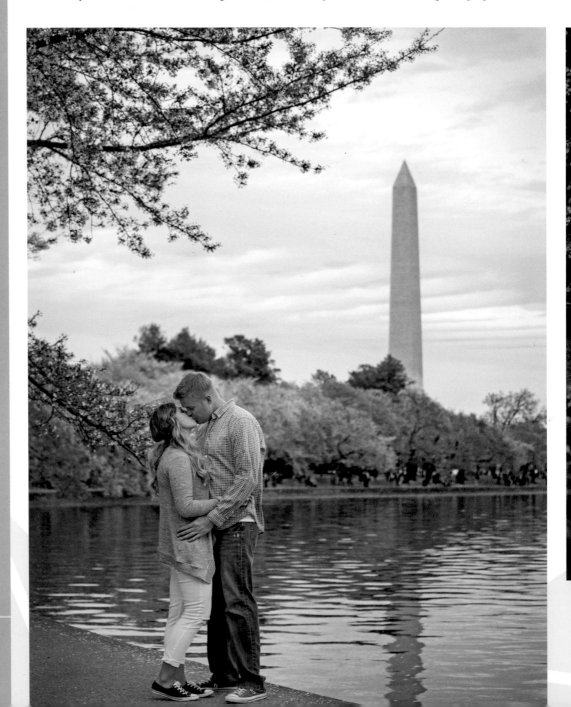

3

THE WEDDING DAY

THE BIG DAY IS HERE and you're ready to shoot. To succeed in taking exceptional wedding photographs, you need to be prepared. Ensure you have backups ready in case of equipment failure, and keep on top of what's scheduled (officially and unofficially) so you're in position and ready to capture the moment.

Shooting a wedding can be a daunting task unless you know what to expect and you have a plan. While every wedding is unique, there are many similarities and your day can run like clockwork if you know when things are going to happen. That is why it is important to be in communication with the couple regarding the details of their wedding day—the times and locations of different events, how they are traveling between locations, how much time they are leaving for different photographs, and how the different locations will be lit.

It is also important to be in communication with the couple well in advance of the wedding day so that you can clarify their expectations and modify the schedule if need be. Unless they have hired a wedding planner or they work in the wedding industry, couples rarely know when things are supposed to happen or how to make the day flow smoothly. Sometimes their expectations are unrealistic. It is much easier to address these issues well in advance of the wedding day than on the day of the wedding itself.

RIGHT
I spoke in depth with the wedding coordinator so I knew the bride and groom had planned a complicated ribbon ceremony. While absolutely lovely, it did decrease mobility, but it didn't faze the success of the shoot because I knew the plan and was prepared ahead of time.

The wedding day

ABOVE
I knew from chatting with the bride that their dog would be attending the wedding but that he would only be there for a brief time. As a result, I kept my eye out for his arrival so I could get a few shots of him before he left.

The biggest issue involves timing. One example is the length of time that's allotted for formal photographs. I have worked with many couples who have chosen beautiful venues for their ceremonies—on the beach in the golden sun or with a dramatic view of mountains framing them in their photographs—yet, when I go over their wedding schedule with them, they have scheduled their photographs well after sunset, when there will be no scenery visible at all. By talking to them ahead of time, we are able to either change the time of the shoot or clarify their expectations. If the times can't be changed, they may consider seeing each other before the wedding, investing in a post-wedding shoot, or I will get them excited about low-light photography augmented by a video light. Perhaps the couple has chosen the perfect time for photographs, but they have only left 20 minutes and they want photographs at ten different locations. I make sure that I tell them how many photographs and what kind of photographs we can take in a given timeframe. It is important to me that the couple has realistic expectations about what can be accomplished in the time they have allotted for photographs. It is also important to have a clear understanding of the wedding party and the families. Are there bitter divorces in the family that will force you to treat the groom's family as two separate families during the formal photographs? Are you dealing with a large wedding party of 30 that will require extra time and attention during the wedding party photographs? Are there grandparents in attendance who are infirm and may not be able to participate in the formals but should definitely appear in other, less formal photographs with the bride and groom?

These are all important questions to ask and will help you on the day of the wedding. Excellent communication between the photographer and the couple and between the photographer and the other vendors is important and can ensure the wedding day runs as smoothly as possible.

Sometimes, the bride and groom have scheduled something really incredible for their wedding, such as fireworks during the first dance or sparklers at the reception, or even a special toast. They deal with so many vendors for their wedding day that they may forget to tell you about every event unless you ask for specifics. When I initially book a wedding, I get a general timeline from the bride and groom and then I correspond with them throughout the planning process. However, a few days before the wedding, I will also have a detailed conversation with them about any special things they might have scheduled and when these things will be occurring. This includes events during the ceremony. It is important that I have a clear picture of what is happening and when so I know where to stand to get the best shot, and so I'm not walking around looking for a better vantage point while they are doing something meaningful.

RIGHT, TOP LEFT
After the ceremony, the bride and groom sailed away. I had chatted with the bride and groom about the sail prior to the wedding day, so I knew that they preferred shots of them from shore rather than shots taken on and around their boat.

RIGHT, BOTTOM LEFT
The bride and one of her bridesmaids joked all day about the origin of these pinecones. It turns out they obtained them when a pine tree fell on the bridesmaid's car and destroyed it, and the story was told several times throughout the day. Even though I generally focus on details as a rule, I made sure to get some extra shots of these placeholders because of the interesting backstory.

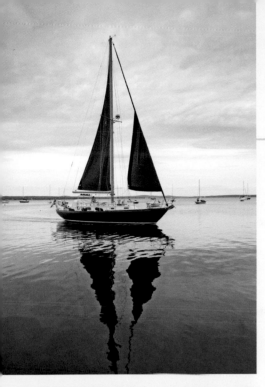

Samantha Verrier

The groom's mom designed and set up the entire tent (with some help from her incredible friends), so I tried to photograph the decorations from many different angles because I knew they were extra special to the groom.

VENUE

Most of the time, the bride and groom have put a great deal of thought into the location of their wedding. I think that it is just as important to capture photographs of the setting as it is to photograph the actual events.

The venue detail will give the event a sense of place. It will often make the viewer remember what it felt like to be at the wedding. I try to arrive early enough in the day so that I can photograph the setting before I ever see the bride. I photograph the spot that they have chosen for their bridal preparations, the location of the ceremony, and (time permitting, and if it is close by) the location of the reception. Not only does this give me a great opportunity to see how things are set up, but it also gives me a chance to photograph the buildings and some of the details that are a part of the setting. I also take this opportunity to scope out some locations for photographs if I haven't already done so. While I am photographing, I poke around the grounds, looking for hidden nooks and interesting spots, conscious of how the light is going to change.

Scouting the venue also gives you a chance to interact with the other vendors. The florist may be decorating, the coordinator will probably be running around the venue, the band may be setting up. If you are there before the event begins, it will give you a great opportunity to chat with some of the other vendors and to hear about any last-minute changes to the schedule or anything else that may be important for your coverage of the event.

BELOW
Sometimes you can capture the venue and the couple at the same time!

RIGHT
If the venue has a beautiful entrance, I'll try to capture it as I drive in.

ABOVE
I needed to capture this venue in Kennebunkport, Maine, from the water.

RIGHT
I love so much about this venue in the Dominican Republic, but it is the shots at night that I find most striking.

PREPARATIONS

Bridal preparations are usually a flurry of activity—hair, makeup, dresses, bridesmaids and relatives running to and fro.

Emotions are running high. You tend to see a whole range during the bridal preparations, from nervousness to excitement and everything in between, and you can often capture some fantastic photographs of the interactions between the bride and her mother and the bride and her bridesmaids during this time.

Makeup application and hair tend to take a long time, and though I take some photographs of both of these things, I don't photograph them non-stop. I ask the bride what time she is planning to put on her dress and then I arrive about a half hour before that time. That usually gives me ample opportunity to photograph the end of hair and makeup and to take many of the detail shots of the room. If I don't have a second photographer working with me, I often float

between bride prep and groom prep until the bride is ready to put on her dress. My general policy is to start photographing the bride getting dressed as soon as she is completely covered, but I usually ask what the bride wants as she may want some photographs in her lingerie as she is stepping into the dress.

For the most part, during bridal prep I am trying to capture the interaction between the bride and her closest friends and family. I look for special moments shared between the bride and her best friends, I look for the hug that the mother gives the bride, or the look on the bride's father's face when he sees her in the dress for the first time. Many brides and bridesmaids will do a toast before they leave for the ceremony, and this is often an emotional impromptu speech made by the bride's best friends.

The bride has usually put a lot of thought into the bridal details, and I try to capture as many of them as I can. I always try to photograph the dress hanging up during the bridal preparations. I also photograph some of the other bridal details—her jewelry, her shoes, an elaborate lace border on the edge of the bride's veil, the bride's engagement ring—all the details that add to the bride and groom's wedding story.

I also take this opportunity to look for other things that may be important to the couple. Signs that they put up to direct their guests to the wedding, flip flops that have been left at the door that say "Bride" on the sole, the note in the flowers that the groom has sent to the bride that morning—I try to capture all of these things in the setting where they have been left. Upon seeing these images after the wedding, couples will often remark that those scenes made them remember what they were thinking or feeling the morning of the wedding or they will remind them of something funny that happened.

After photographing the bride's dress going on, I try to pop over to catch up with the groom. While bridal preparations are similar from wedding to wedding, the groom's preparations are often vastly different. Most grooms do not spend anywhere near the amount of time

RIGHT
These days, everyone has a camera. Have fun with them!

BELOW
The bride's brother walked in to wish her good luck on her wedding day.

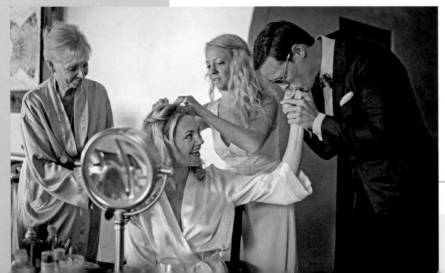

RIGHT
It can be fun to find creative ways to capture both the bride and the groom in the frame pre-ceremony.

BELOW
I usually photograph details like the rings at the start of the day.

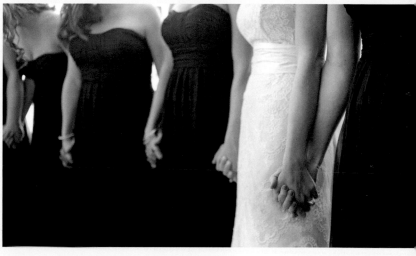

getting ready that the brides do, so they fill their time with various activities. Some grooms will go golfing, some go to a bar, some sleep, but we always try to photograph them doing whatever it is that they choose to do on the morning of the wedding. Our cameras are time-synchronized, and most brides will get a kick out of looking at the proofs and being able to see that while she was applying her makeup her groom was watching cartoons and drinking a beer.

ABOVE LEFT
If the bride has a special hairpiece, I will try to grab a few photographs of it during the preparations.

ABOVE RIGHT
The bride and her bridesmaids had a prayer circle before the ceremony. I photographed their joined hands to capture the spirit of the moment.

THE FIRST LOOK

Many couples are choosing to see each other before the ceremony. Whether they have decided to see each other for personal reasons or for ceremonial reasons (at a Jewish wedding the bride and groom will see each other before the large wedding ceremony to sign the Ketubah), it is fun to set up a "first look" shoot for the bride and groom.

At most ceremonies, the groom sees the bride for the first time when she walks down the aisle. However, at that time they are in the middle of the ceremony and it usually isn't the proper time for the groom to sweep the bride in his arms and tell her how beautiful she looks and for the bride to give the groom a quick kiss and tell him how excited she is that they are getting married. In other words, when the bride and groom see each other for the first time during a ceremony, they are not sharing an intimate moment. If you set up a "first look", you can capture the intimacy of that first moment. It gives them the time to react to one another and to tell each other how they are feeling and to hug and kiss prior to the start of the ceremony. Not all brides and grooms want to do one (some still stand by the superstition that the groom shouldn't see the bride prior to the start of the ceremony), but those who do are giving you a great opportunity to capture a meaningful moment. I often choose a longer lens and try to maintain some space between me and the couple to give them the feeling of privacy.

BELOW
I love to photograph the anticipation on the groom's face as the bride gets into position for the first look.

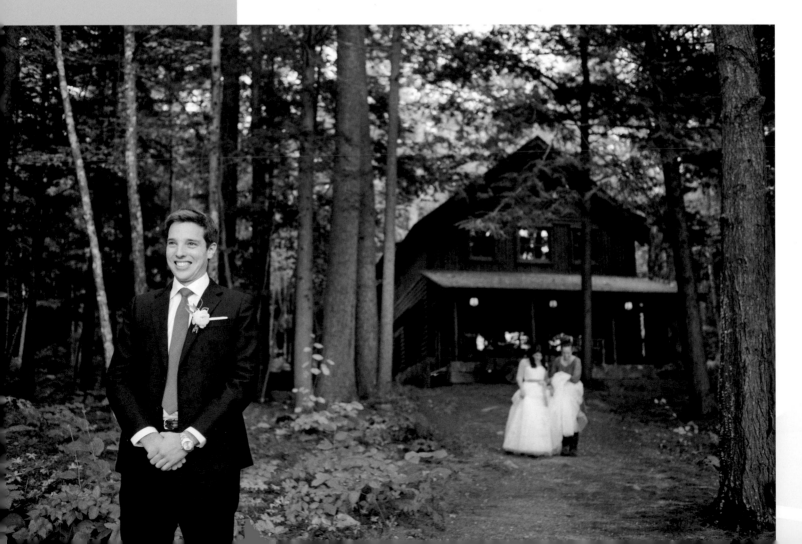

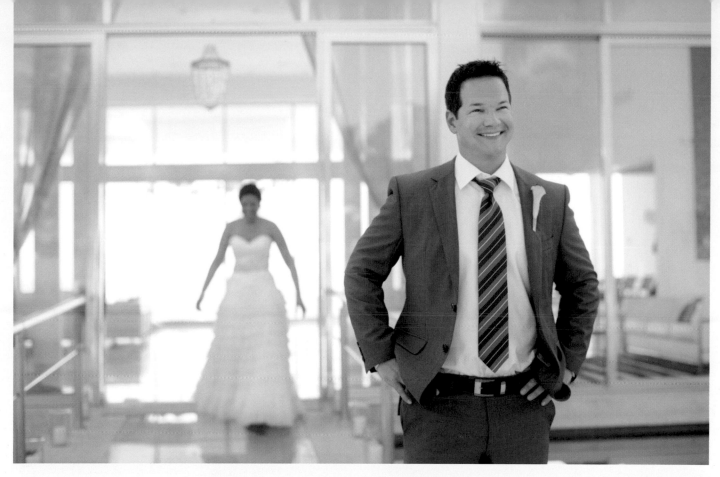

ABOVE
Position the groom in good light for the first look and then bring the bride to him.

BELOW LEFT
I include the bride in the frame as I capture the groom's face during the first look to give the image context.

BELOW RIGHT
Choose a spot that is away from any onlookers so that the bride and groom can have a private moment.

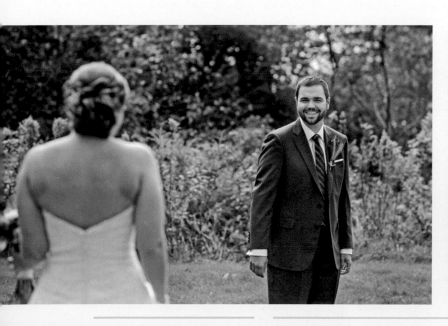

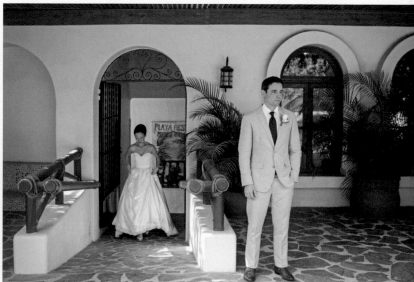

CEREMONIES

I like to know all the details about the ceremony location and how it is going to be lit well before the wedding day as it will affect which lenses and equipment I bring.

Most of the time, I shoot with a combination of my 35mm f/2 and my 85mm f/1.4. However, if I am working with a large ceremony or if I have limited mobility (some churches have strict rules about the movement of the photographer and the locations from which they can shoot), I will occasionally use my 180mm f/2.8 to give me some extra reach and flexibility.

If the ceremony is inside, I also like to have a general layout of the church or building. Sometimes there are balconies or doors to the side of the altar, and I like to make sure that I know how to get to them and if they are going to be unlocked. In churches that do not have a center aisle, I need to make sure I know whether the bride will be walking up the left or the right side, and I like to choose an alternate vantage point (other than the center aisle) for the exchange of rings and the kiss.

If the ceremony is outside, I will usually have more flexibility and mobility. If there is strong backlighting, I may need to use a little fill flash to lift the shadows in the faces (although this is not something that I do often). For the most part, I use existing light and a long lens (my 85mm) during the ceremony, interspersed with my fisheye lens to capture the ceremony location. I like the long zoom on Aperture-Priority mode, wide open because it allows me to stand at a good distance from the bride and groom and still separate them from the background effectively.

I plan to arrive about ten minutes before the bride arrives, and I use that opportunity to take some test exposures, to photograph the interaction of the guests, and to photograph some of the details of the ceremony (flowers, candles, and other decorations). When the processional starts and the mothers are walked down the aisle, I position myself at the front of the aisle (to the side, usually crouched down) so that I can photograph the mothers, the bridesmaids, and the bride coming up the aisle. From this vantage point, I am also able to swivel quickly and photograph the groom's face as the bride comes up the aisle. If I have a second photographer with me, I will position her at the back of the ceremony so that she can photograph the back of the bride's dress with everyone swiveling to look at her.

After the processional, I head to the back of the ceremony. I like to use the balcony, if available, to shoot down on the ceremony and to take some wide-angle shots of the entire room. I also like to roam from side to side, remaining unobtrusive while I capture the expressions on the faces of the bride and groom as well as their parents in the front row.

BOTTOM LEFT
Ask the officiant if there are any places where you can capture interesting angles without disturbing the ceremony. This was taken from a hidden door to the right of the altar.

BOTTOM RIGHT
Using a long lens can help you capture the action without needing to approach the couple.

TOP LEFT
The recessional is one of my favorite moments to capture. I love their expressions!

TOP RIGHT & BOTTOM
You may be able to grab a beautiful shot of an outdoor ceremony from a distance, but make sure you know the timing so you don't miss anything important!

The time immediately following the ceremony is one of my favorite times to photograph during the wedding day. The bride and groom (and their family and friends) are often very emotional immediately after the ceremony. Often the bride and groom will take a few moments by themselves. I like to capture these photographs from afar—a tender touch on the cheek, a tearful hug, a series of unbelieving smiles and laughs. I like to photograph these moments with a longer lens to give them the feeling of privacy. As they are joined by their friends and family, I switch to a wider-angle lens (usually a 35mm or 24mm and sometimes even a fisheye) so that I can capture the group hugs or impromptu toasts.

Some couples choose to have a receiving line after the ceremony while some leave immediately to start the formal photographs, and still others stage interesting exits from their ceremony site. If the bride and groom are doing a receiving line, this is a great opportunity to photograph candid shots of the bride and groom being congratulated by individual guests. I usually photograph these with a longer lens so I can maintain some distance, and I alternate between positioning myself behind the bride and groom to capture the faces of the guests, and positioning myself in front of the bride and groom to capture their faces. Sometimes the bride and groom will stage an exit and will exit the church or building while the guests throw flower petals or rice or blow bubbles. If they do this, I like to switch to a wider-angle lens (a 35mm or 24mm) so that I can capture the bride and groom as well as those around them in the act of throwing rice.

Sometimes the bride and groom have hired interesting transportation for the day— horse-drawn carriages, trolleys, antique cars, or limos. I like to swing out into the road (carefully, of course) to photograph the car in the foreground and the ceremony site and guests in the background. I like to use a wide-angle so I can fill the frame with both elements.

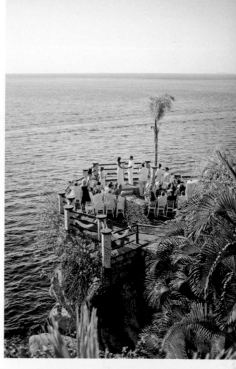

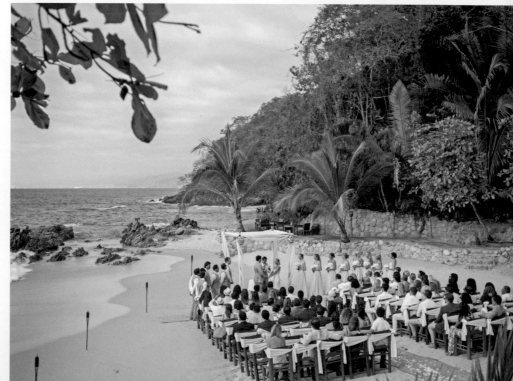

FORMALS

I try to have a few different locations chosen for the formal photographs ahead of time—the first for the formal family and wedding-party shots and the rest for images of the couple. The amount of time allotted helps me determine which locations to use.

If we don't have much time, I'll scout for locations close to the ceremony or reception sites. For the family formals, I try to find a comfortable, accessible location with some flattering light. If it is overcast or you are in open shade, a technique for finding good light is to have your assistant turn in a circle while you watch how the light falls on them from every direction. If you don't have an assistant, this is easily accomplished by holding up your arm and seeing how the light falls on your hand and forearm. Notice that, as you turn in place, the light will change; sometimes it will produce unflattering shadows and sometimes it will fall evenly in a flattering way. I usually want to find a spot that's out of the direct sun (especially if it is in the middle of the day in the summer) that is accessible for people with canes and wheelchairs. I try to choose a location that will be good for expressions rather than one that will be good for capturing the view; it is more important to capture family formals in which the family members are not squinting or sweating profusely in the direct sunlight. If there is no good, shady spot around, or if the bride and the groom really have their hearts set on taking the formals in a certain location, I may need to add some fill flash.

If I need to photograph the group in the direct sun, I try to position the sun behind them and slightly off to one side. If the sun is directly behind them, I may lose contrast or pick up some unwanted lens flare. The farther to the side I place the group in relation to the sun, the better my odds are for remaining flare-free. However, I want to be careful not to turn them too far because I don't want a highlight from the sun on the sides of the faces. And while flare can be pretty in some creative shots of the couple, I definitely don't want a lot of flare in my formals. Once I have the location picked out, I do a test exposure for the background to determine the settings for retaining a bright blue sky or a reflection on water without blowing the highlights. I usually have to stop down quite a bit so that I can stay under my flash sync speed of 1/250. While I could use high-speed sync, I choose to remain within my maximum sync speed because I will be taking a lot of images in quick succession and I want my flash to fire and recycle as fast as possible.

I set up my flash on a light stand behind me and slightly to the side—not too close or too far to the side or I'll become a victim of the inverse square law and my light will fall off too quickly as it moves across my group. Occasionally, I'll add a second off-camera flash on the other side to balance out the image. If you are balancing bright sun and you are using speedlights, you may find that you need to use a full-power flash (or perhaps 1/2) in order to give you enough light to properly expose your subjects against the bright background. If you are at full power, be careful how fast you shoot. Your flash may not fire at all if you aren't giving it enough time to recycle in between images or, if it does fire, it might not give you enough light. I use my Profoto lights when I can. They are powerful

BELOW
Often the best location for family formals is the place that has the best/most even light.

and I don't need to worry about the level of light or the recycle time when I use them.

I can't stress enough how important it is to know about any divorces in the family prior to the start of the family formals. Imagine a scenario in which the parents of the groom are divorced. You will need to know whether the bride and groom want to treat the divorced family as one big family (all of the parents together, even if they are remarried) or whether the couple want to treat the divorced family as two separate families. Occasionally, the couple will choose to treat it as three separate families (the groom's biological parents, the groom's mom and her family, the groom's dad and his family). This is an awkward conversation to have in front of all of the family members. It's best to establish what the couple wants to do about family images beforehand.

With a typical family I will take the following photographs in this order (and then repeat it for the groom's side of the family):

1. Bride & Groom & Bride's Extended Family: I position the bride and groom in the center of the photograph with parents and siblings next to the bride and groom. I ask everyone else to fill in.

2. Bride & Groom & Bride's Immediate Family: I simply ask the extended family to step out of the previous shot. I already have the immediate family in position.

3. Bride & Groom & Bride's Parents: I ask the siblings to step out of the previous shot. The bride, groom and parents are already in position, so these images happen very quickly.

4. Bride & Bride's Parents: I ask the groom to step out of the shot.

5. Bride & Bride's Mom: I ask Dad to step out of the shot.

6. Bride & Bride's Dad: I ask Mom to step out and Dad to step back in.

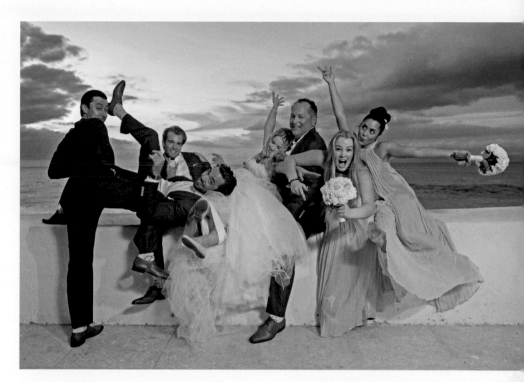

7. Bride & Siblings: I ask the siblings to step in again. Occasionally I'll also photograph the bride with each sibling individually, if she'd like the image.

8. Bride & Grandparents: If the grandparents are infirm or mobility impaired then I may do this shot first so that the grandparents can go and sit down or I may postpone this shot until later during the reception.

ABOVE
I have a few "regular" photographs of this couple and their children, but this is one of my favorites. I lit this image with a Profoto shoot-through umbrella to capture the sky while properly exposing all the people as well.

WEDDING PARTY

I have never come across a wedding party that is excited to take photographs. Most of them have been to weddings where they do a lot of standing around and waiting after the wedding, and usually after the ceremony they would settle in for the long haul of formal photographs when all they really want to do is get to the party.

I try to change all that in the first few minutes of working with the wedding party. I want to keep everyone happy while capturing meaningful photographs of the people most important to the bride and groom. First, I start with a very simple standard photograph of the bridal party. This is the one that they are expecting. Personally, I like to break up the sexes, so I will ask everyone to find the person that they walked out with. This will quickly separate them into guy/girl pairs. If they have an uneven number or a mixed wedding party

BELOW

If I have plenty of time with the wedding party, I'll try to stagger them in the frame.

(men that stood up for the bride, or women that stood up for the groom), I will just quickly sort them myself. I place half of them on one side of the bride and groom and half on the other side. If I have a group with radically different heights I may shuffle people around, but I don't micromanage these shots too much. I want them to feel natural and relaxed—well, as natural and relaxed as things can feel when you are standing around in a line in a suit in the sun having your photograph taken!

It is important to observe the details. They may not be that noticeable while you are working with the group, but you will definitely see them in the photographs. Make sure that jackets are straight, sunglasses are off, and that hands don't look awkward. The women are simple to adjust because they usually have bouquets to hold and I will just make sure that they are holding them at approximately the same level. Most of the time I will ask the men to put their hands in their pants pockets. This will give the group a more relaxed look while doing something with those otherwise awkward-looking hands. If anyone is standing straight on to the camera, I simply ask them to turn in slightly to the bride and groom while putting their weight on their back foot. This makes them unlock their knees and puts them in a much more flattering position. This whole process (from the line-up to the photograph) takes no more than three minutes.

If the bride and groom are itching to get to the cocktail hour, we'll stop there. Occasionally they want to continue, and then I make sure to get the group moving around. Most of the time, I have them walk toward me while they are lined up. I simply ask them not to look at me, but rather to look at one another while talking and walking. Occasionally they ask for a jumping shot, and while it is not standard, I am happy to comply. It all depends on the personality of the group as a whole. Once they have loosened up, if they still want more, then I'll move right onto the environmental portrait. This takes the longest to set up because I try to

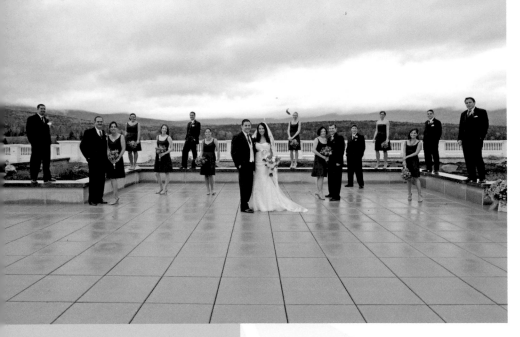

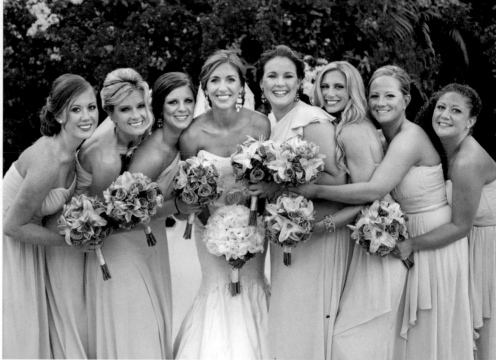

achieve a balanced composition with it, so I'll only do it with wedding parties that are really into being photographed and have a lot of time to burn. To create this, I use elements of the venue or of the environment itself—rocks on the beach, a wall, stairs—and I stagger members of the wedding party. Everyone has something different to do—stand, sit, or lean. This is easier in some locations and more difficult in others, but I try to do one of these photographs (time permitting, of course) at almost every wedding.

Finally, I will usually split them up into two groups—the bridesmaids and the groomsmen (unless the bride and groom only want photos of the group as a whole). I will give one of them a break while I work with the other group. I try not to take more than five minutes with each group so that there is a minimum of standing around. I will quickly do a shot of them lined up together and then, if we have extra time, I will try to do something more creative using selective focus or staggered posing. While I have them separated into groups, I will usually take a quick shot of the bride with each of her bridesmaids individually and the groom with each of his groomsmen individually. Make sure that you keep shooting, because after the "formal" shot is taken, a very real moment (a hug between bridesmaids and the bride, a congratulatory "high five" between the groom

and the groomsmen) could occur. From time to time (but not often), the bride and groom have fun props or accessories for their wedding, I will try to integrate them into one of the group photographs. Sometimes they bring props for a photobooth and those are fun to grab and use. Each wedding party is different, and I take the personality of the group into account when I decide how silly we will get with the wedding party shots.

ABOVE LEFT
Capturing the groomsmen looking at the camera is great, but it is good to get them moving too.

ABOVE RIGHT
If your first few shots look a little stiff, don't be afraid to ask them to get closer.

BRIDE & GROOM

Most couples come wanting something a little different—elegant environmental portraiture rather than a series of them looking at the camera and smiling.

However, while the couple may want to veer in a different direction, I try to remain cognizant of the fact that their parents and grandparents will likely want the shot of the couple looking at the camera and smiling.

As soon as I am finished with the wedding-party shots (and I dismiss them to the cocktail hour so they don't distract the bride and groom), I set up the couple for this standard portrait. Generally I have them form a "V" so that they are slightly facing each other while also facing the camera. The bride will usually be holding a bouquet, so pay attention to what the groom is doing with his hands. Some grooms don't have any idea what to do with their hands. They will put one arm around the bride, but they leave the other hand awkwardly floating out in space. Give them something to do with that hand. You can have them put it in their

pants pocket for a casually elegant feel. If you want a more traditional portrait, have the groom put one arm around the bride's back and bring the other hand up to hold the bouquet with the bride to center it between them. If they are very comfortable together from the beginning then I will have them press their cheeks together (or, if there is a significant height difference I will just have them "snuggle in together"). Generally the bride and groom are at their stiffest at the beginning of our short session together, so I give more direction for this first shot and less direction as they loosen up and start having fun.

Pose one goes directly into pose two. I ask the bride to drop her flowers on the ground, and go chest-to-chest with the groom. She puts her arms around the groom and he puts his arms around her (like they are giving each other a hug) and then they turn their heads to look at the camera. Pay attention to the arms of the bride here. If the bride has an ill-fitting dress or if her arms are a bit bigger (or even if they are tiny but she has demonstrated at some point

RIGHT
The bride and groom share a post-ceremony toast.

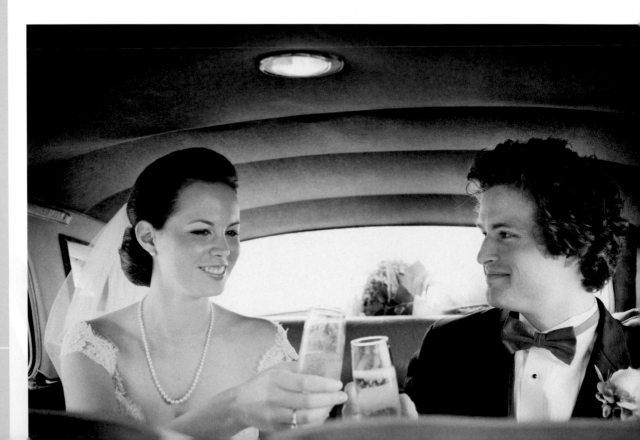

TOP LEFT
It was raining after the cermony
but I was able to capture the
venue and still keep the couple
under cover.

TOP RIGHT
The bride looked at the groom
so sweetly, so I threw on a long
lens and positioned myself to
capture her expression.

BOTTOM
I loved these flowers, so even
though this was in a parking lot in
front of the venue, I made sure
to grab a few images here.

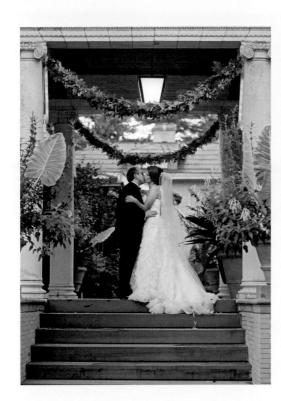

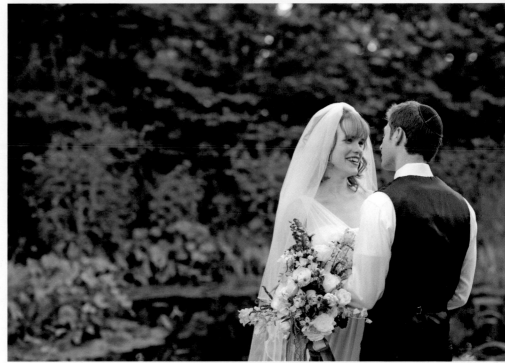

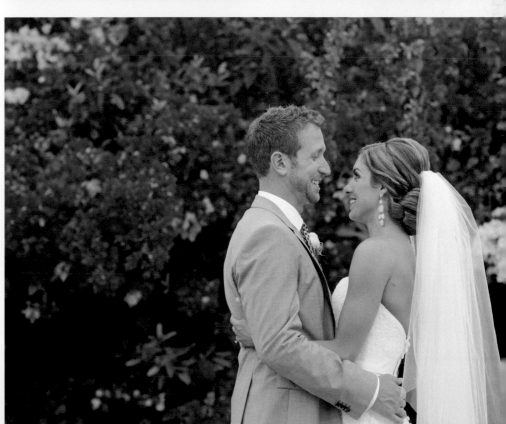

during the day that she is self-conscious), make
sure that her arms are around the groom's waist,
in between his body and his arms, so that his
arms are on the outside and appear bigger.

As I do for the rest of the day (except for
the group photographs and the open dancing,
when I am at $f/4$), I am shooting with a shallow
depth of field. I am generally at an aperture of
$f/2.2–2.8$ for this series of photographs. I
usually photograph these first two poses with
the same lens that I used for the family and
wedding party (generally my 50mm or 35mm).
Pay attention to the perspective of the lens. If
you are shooting with a wide-angle lens (35mm
or wider), make sure that you are far enough
away from the bride and groom that you don't
distort their bodies.

With the next shot, I like to demonstrate the
"formal" poses are over and that we are going to
start the fun shots. At this time I like to have the

The wedding day

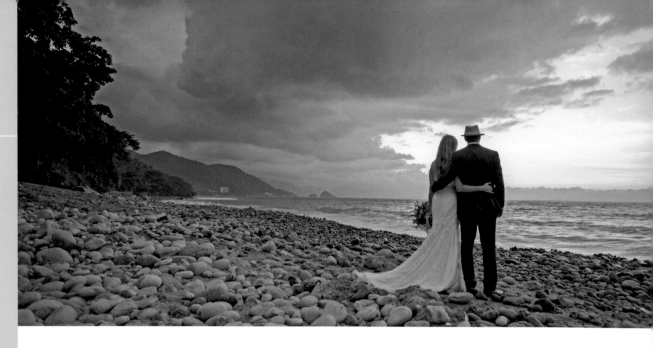

RIGHT
The bride and groom don't always need to be facing you. I love to photograph them as they walk away.

couple face each other and hold hands, leaving a bit of space between them. I will throw the fisheye on the camera, lie down between them, and have them lean in and kiss while I photograph them. It's a fun shot, and it is different from any other shot they will have of the two of them throughout the day.

While I am on the ground I will switch over to my 35mm or 50mm lens and take the bride's bouquet and put it in front of me on the ground. Then I ask the bride and groom to walk hand-in-hand away from the camera, capturing the bouquet in the foreground and the couple in the background. Since I am shooting wide open (or close to it), the couple will be pleasantly out of focus in the background. After I have one or two shots of the bouquet with the couple as a backdrop, I stand up, put my 85mm $f/1.4$ on the camera, and photograph them walking together (which they are still doing from the last shot). I tell them at the beginning of the stroll to take it slow, so the slow speed usually gives them a lot of time to look at each other and chat while they are walking. At some point I will have them stop and kiss (providing me with a great opportunity for an environmental portrait), and then start walking back toward the camera. If you have a very camera-aware couple, you may have to ask them not to give you the "deer-in-headlights look," but to keep talking and looking at each other.

When we reach this point, about five to ten minutes have elapsed since we started the

bride-and-groom photographs. I assess (prior to the wedding day and then again on the wedding day itself) how much time they want to spend taking photographs, and with some of my couples we might have time for one good environmental shot and that will be it. If this is the case, I choose my favorite backdrop and set them up (see the environmental portrait section at the start of chapter two for more details). If I feel that we can take our time, then we will gradually hit a few different locations that provide interesting backdrops and I will play around with my lens choice, perspective, and posing options.

"If you have a very camera-aware couple, you may have to ask them to keep talking and looking at each other"

There are times when the end of the ceremony and the time alloted for the formal photographs will not coincide with the best light. This is especially true of daytime or late-morning ceremonies. If it is a sunny day, you may have a bride and groom that are squinting at each other. I always know what the sunset time is, and if it is really bright I will either suggest they go and enjoy the cocktail

ABOVE LEFT & RIGHT
Don't forget to turn the couple around and use different types of light. I love the look of backlighting (top left), but I also love to capture couples in direct sunlight during the "golden hour" as the sun is going down (top right).

hour and that we get together again for five minutes of photographs before dinner, or (if sunset is still a long way off) that they enjoy cocktail hour and dinner and that we sneak away for a few minutes after they are finished with their meal. The bride and groom usually eat first, so they will be finished with their meal well before the rest of the guests and they won't even be missed at that point. Be sure to talk to your coordinator or event planner prior to scheduling anything like that, though, as you may be cutting into a special event like cake-cutting or speeches. However, if you can make it work, it is a fabulous idea to photograph the bride and groom in the golden light just prior to and during sunset. It will also give you a great opportunity to take some sunset shots as well.

During the consultation stage, many of my couples ask, "What if it rains?" It is good to talk about the possibility before the day. I am able to convince most of my couples that photographing in the rain and in the cold can be fun, and most will choose to do some photographs outside, even in a downpour or in the snow.

ABOVE
Be ready for the real moments that happen between the poses.

LARGE GROUP SHOTS

A lot of my couples want a nice group photograph of all of their guests. I love taking this shot, but it is important to know your location well before you promise this shot to the bride and groom.

You will either need to stagger the group (by using steps or something that gives you different levels) or by getting up high and shooting down on the guests. If you are shooting down on them from a few stories up in the air, you don't have to worry about positioning as much. Everyone will be looking up at you, so no one will be hidden. I ask the bride and groom to stand in front, and then everyone else crowds around and looks up. If you are staggering the group and shooting them from the same level or below, it is important to pay more attention to the positioning. There are always some people who will try to stand behind others. I try to tell the group that no one should be behind anyone else unless they are on a different step. You will also need to be aware that some of the older folks in the group may not be able to navigate stairs well, so you should encourage them to stay near the bottom row.

RIGHT
This couple gave their guests fake mustaches, so I made sure to get a group shot of the mustachioed crowd.

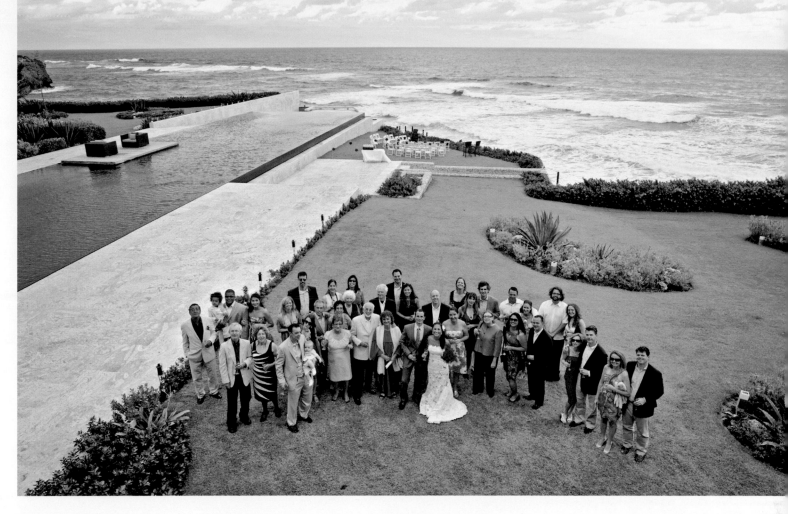

ABOVE
I wanted to photograph the beautiful background in this image, so I took this group shot with a wide lens.

BOTTOM LEFT
The bridge at this venue was a great place for a group photo!

BOTTOM RIGHT
I use stairs to elevate people in group shots if I can't get above them, but it helps if you have folks who are willing to get down in the image, as well.

THE COCKTAIL HOUR

During the cocktail hour I like to throw a longer lens on my camera so that I can take photographs of guests having a good time when they are less camera-aware. A longer lens lets me stand far enough away to be able to capture real moments between the guests and the bride and groom.

The vast majority of couples do not have a receiving line after their ceremony, so the cocktail hour is going to be full of congratulatory hugs and happy greetings. Although I like to follow the bride and groom and capture candid moments, I also pay attention to the family and wedding party members. Other than the bride and groom (who usually spread themselves out to greet everyone), I have found that people gravitate toward those they know best during the cocktail hour. Therefore, you can generally catch mom with her lifelong friends or dad with his favorite cousin who moved to Alaska.

I like to keep a second camera body with me with a wider lens attached so that I can easily photograph a grip-and-grin shot of these groups as I move around.

Cocktail hour is also a great time to capture the bride and groom with some of their informal groups. If they want a photograph with their friends, colleagues from work, or family from across the country, this is a nice time to capture that. I generally tell the bride and groom to work the cocktail hour and visit everyone, but to wave me over when ready and we will take the photograph at that point. That way the bride and groom feel that they can relax and that the formal photographs are over, but we are also taking advantage of some of the "free" time they have to take some of those extra photographs that are important to them. Sometimes they'll want quite a few shots, and sometimes they won't want any at all and they want me to focus on candids instead. I let them take the lead here.

BELOW
This couple was announced at the end of their cocktail hour. I love their expressions!

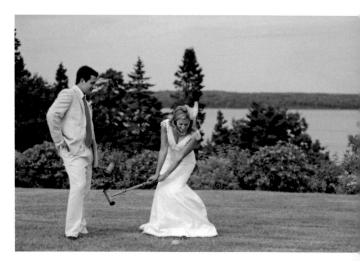

ABOVE
Lawn games are popular during the cocktail hour. I kept an eye out for the bride and groom to see if they were joining in the fun.

TOP LEFT
Find out where the bride and groom will be announced. You may need some lighting, so be prepared.

TOP RIGHT & BOTTOM
The cocktail hour can be a great time to capture a wider image of the venue.

RECEPTION DETAILS

The reception is usually the result of many months, sometimes years, of planning. The flowers, the silver, the covers on the chairs, the centerpieces, the band, the place cards, the food itself—all are details that the bride and groom have spent a long time working on and I try to capture as much of them as I can.

I want the bride and groom to look at the photographs and remember not only who was there, but also what it felt and looked like to be there. I try to photograph many of these images as early in the day as possible—tables never look quite as good once the guests have started eating, and most couples are going to want a photograph of their cake before they cut into it.

If you are photographing the ceremony and reception at one location, it is sometimes possible to photograph the reception details prior to the start of the ceremony. I like to check with the florist and the coordinator to see when they plan to have the room (or tent) ready, and if it is hours before the ceremony I will arrive early to photograph the details while they are fresh. If not, then at some point during the cocktail hour I will try to sneak away and photograph the reception details before the guests enter the room or the tent.

Look for the things that will be moved or might disappear and start there. I typically start by photographing the table assignments as those cards (or favors) will move as soon as the guests enter the room. Next I take a wide-angle photograph of the entire room. I try to do this without flash so that the ambient light and the "feel" of the room are maintained. This is also a good time to document the centerpieces and the cake (if it is out), as well as any children's favors, interesting bar setups, chandeliers (or any special lighting), or lounges. More brides are providing baskets of flip flops for their female guests to change into once they start dancing—these are fun and the colors usually match the wedding colors.

BOTTOM LEFT
I used my macro lens to photograph these table assignments.

BELOW
I have tight images of these beer bottles and flowers, but I love the wider shot of the three stools together.

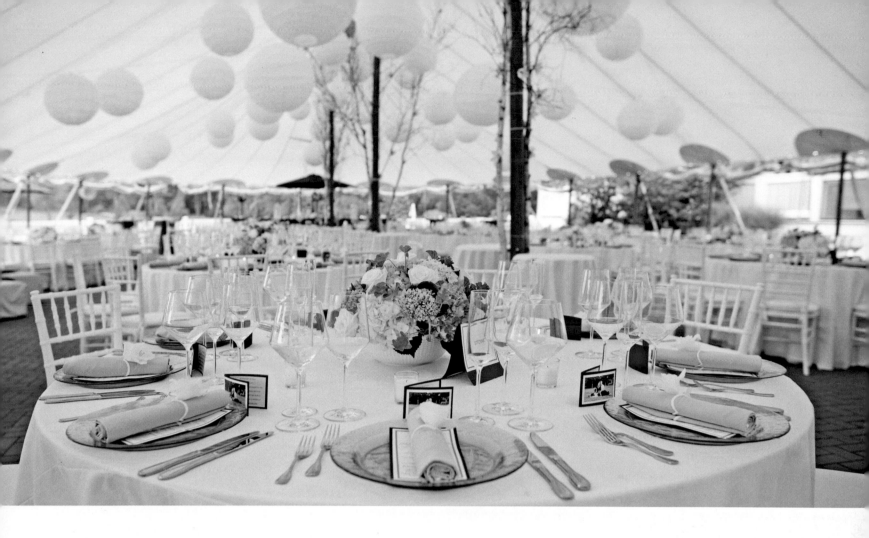

ABOVE
I snuck into the tent before the guests arrived in order to capture the undisturbed place settings.

BOTTOM LEFT
A long lens was the perfect tool to blur out the crinkled tent in the background of this centerpiece photo.

BOTTOM RIGHT
Don't forget to photograph the decorations on the cocktail tables, as well!

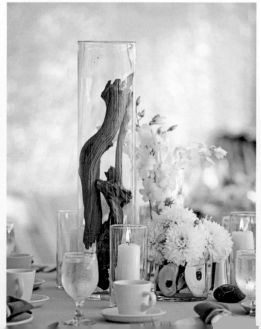

CHILDREN & PETS

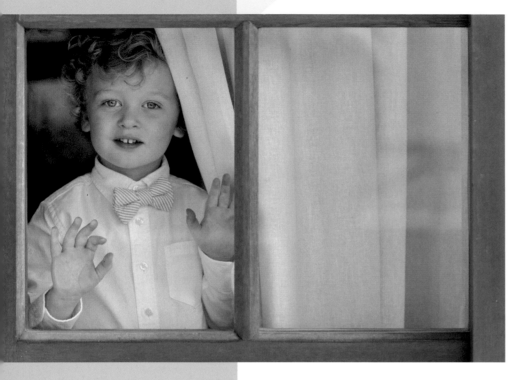

I snapped a photo of this ring bearer sneaking a look at the ceremony site before the wedding.

Being a mom of two, I in no way confuse my big furry Bernese mountain dog with my two rambunctious boys, but when photographing any of the three I employ the same strategies.

Both children and pets are fantastic subjects for photographs at weddings, and both can move quickly or react unexpectedly (especially if they see the camera pointed in their direction).

First, I try to photograph them quickly. Patience is not usually high on the list of attributes of either child or furry friend, and children especially tend to tire out and make a quick exit from the reception. Second, I like to know their role in the day. Are the children walking down the aisle? Are the pets? On a particularly happy occasion, the children walked the dog down the aisle and it became one of my favorite photographs of the day. I try to be

prepared for a number of scenarios and will station my second shooter (if I have one) accordingly in case things do not go as planned. Third, I assess the personality of the child (or pet) before I choose my lens. If I am working with a particularly shy or rambunctious subject, I will choose a long lens so that I can photograph them from afar. If the subject is easy-going, I feel more comfortable getting in closer to them and will choose a wide-angle lens, generally something in the 35–50mm range.

"If I am setting up a formal photograph I will usually add a small child last, as they do not normally have the patience to wait"

I watch the expressions of the children as the day progresses. Their faces usually show exactly what they are thinking if you don't interrupt them. I try to capture the excitement on the face of the flower girl as she puts on the pretty dress that she has waited so long to wear, or the look of boredom on the face of the ring bearer during the long ceremony. Occasionally you can even catch the kids nodding off! I try to capture the dance floor, as the children are usually the first ones out there dancing. If there are any members of the wedding party or immediate family of the bride and groom that have children in attendance, I always try to take a quick photograph of their family—it is not often that the young children are dressed up and everyone is together, and they usually appreciate it and purchase the photograph later. It is important to remember if there are young children in the wedding party you may not have time to compose the perfect shot. If I am setting up a formal photograph I will usually add a small child last, as they do not normally have the

TOP LEFT
It's difficult to tell whether children will run down the aisle or walk slowly, so be prepared to capture fast movers, too!

TOP RIGHT
Be sure to capture pets in their special wedding attire.

BOTTOM
The bride and groom hugged their flower girl immediately after the ceremony. This is one of my favorite shots from the wedding.

patience to wait while other people are being shuffled around. There will be times when the children cannot wait to be photographed, and also times when they will be crying. I do not try to force a photograph with a child. If the bride really wants a photograph with the flower girl and the flower girl is crying, I try to convince the bride to save the photograph until after the child has taken a rest. A really great strategy I have developed for working with children during formal photographs is to involve them in the process. They have been told what to do all day, and sometimes letting them make a decision or giving them a task can make the experience fun. I love showing them the back of my camera. I'll even let kids take a photograph with my camera (while I'm holding it). Sometimes I can get a reluctant child to jump in the photograph simply by promising that if they pose for one photograph, they can take the next one.

SPEECHES

This is one of my favorite parts of the reception because emotions are running high. I have never seen a series of speeches that didn't produce laughs, tears, smiles, or fantastic looks between the bride and groom.

The people giving the speeches are almost always the people who are most important to the couple, so it is a good opportunity to get some great shots.

Everybody (most of the time, at least) is stationary, so I find it incredibly easy to take photographs, even in the darket of venues. I try to capture three things during the speeches: the speaker, the bride and groom reacting, and the other guests reacting.

I try to take a mixture of photographs that use available light (with my $f/1.2$ and $f/1.4$ lenses) and flash images (dragging the shutter to bring up the ambient light). If the light is good, then I may switch to just using available light, but quite often I'll find that either the faces of the speakers or the faces of the bride and groom will be in partial shadow, so having flash images as well will give me some variety

in the photographs, encompassing both well-lit and true-to-life work.

If I have a second shooter with me, I will position him or her in a good location to photograph the speaker while I photograph the bride and groom's reactions. This is a great opportunity to capture a series. There will often be a wonderful variety of different expressions in quick succession, and you can capture the spirit of the speech by photographing these changing expressions. If I don't have a second photographer, I'll switch my focus between the speaker and the bride and the groom, generally starting with the speaker to get some safe shots, then moving into a position where I can capture reactions.

Sometimes it is impossible to get both the speaker and the bride and groom in the same photograph due to where the speaker is standing. However, I always try to get at least one series of photographs in which they are all in the same frame. If they are facing one another, I may frame the bride and groom with the speaker's out-of-focus side, or frame the speaker in the space in between the bride and groom's heads to make a more dynamic photograph.

BOTTOM LEFT & RIGHT
I like to photograph the speaker two ways if possible: on their own (left) and with a group of people reacting in the background (right).

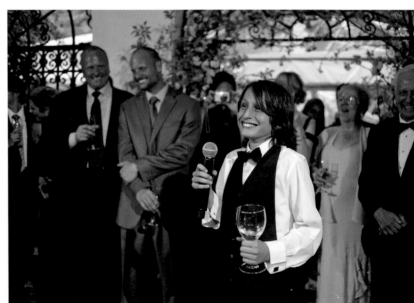

TOP LEFT
I used a long lens to photograph the bride and groom during this speech.

TOP RIGHT
The grooms had so many wonderful reactions during this speech. I captured them from several different angles.

BOTTOM
I used a wide lens to capture the guests toasting behind the bride and groom during this speech.

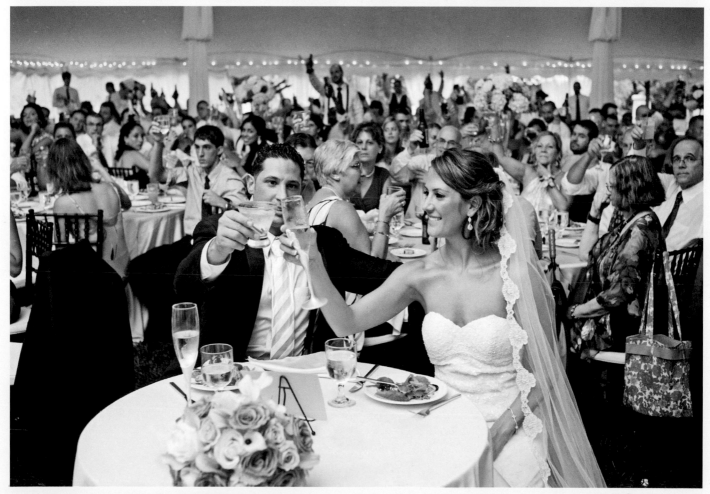

THE FIRST DANCE

Whether the bride and groom have choreographed their first dance or they are just winging it, you can produce some beautiful photographs.

I like to photograph this part of the reception with a very shallow depth of field so that the bride and groom are in sharp focus while you can see the crowd standing around observing, pleasantly out of focus. I tend not to use flash here, but if I need to add flash I like to balance it with ambient light, usually by bouncing the flash to one side or the other.

In general, I like to photograph the first dance with a 35mm or 50mm lens because then I can see what else is going on in the frame. I like to see the expressions of the parents while the couple is on the dance floor, and will often catch a tear or two rolling down someone's cheek.

Be sure to chat with the couple about the first dance before it happens, as they will sometimes have a surprise up their sleeves. I have had occasions when the couple has started off elegantly enough but then stopped mid-song to stage a fun and rambunctious dance-off. On other occasions they have changed their outfits and on others they have pulled their friends and families onto the dance floor to dance with them.

On one interesting occasion, the first dance was a signal for the fire-juggling act to begin, and on still another they had a fireworks display in the middle of their dance. Bridal blogs and magazines encourage brides and grooms to highlight their individuality throughout the day to really make the wedding day their own, and brides and grooms are coming up with some fabulous ways to do just that during the first dance. The more you know about the schedule of events, the better.

At most receptions there will also be two other formal dances. The bride will dance with her father and the groom will dance with his mother. Most of the time they will do so to two separate songs, but sometimes they will dance to the same song. If one of the parents is absent, the bride and groom will sometimes invite all of the remaining parents onto the dance floor for a group dance or a grandparent will stand in. I love it when they include both parents in each set. In this scenario, the bride dances with her dad and the groom asks the mother of the bride to dance (and vice versa when the groom dances with his mom). There are many different variations, so I always try to find out from the couple what they are planning to do. I try to look at the guests that are around the dance floor while these dances are happening so that I can capture the expressions of the onlookers. For example, if the bride is dancing with her father, I will try to capture them in focus in the foreground while the bride's mom watches from the edge of the floor.

RIGHT
The decorations were very important to the bride and groom, so I shot wide to include them.

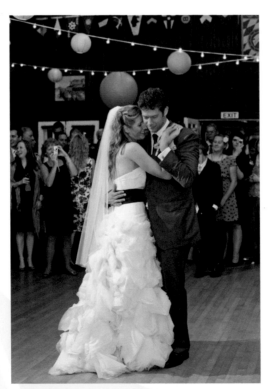

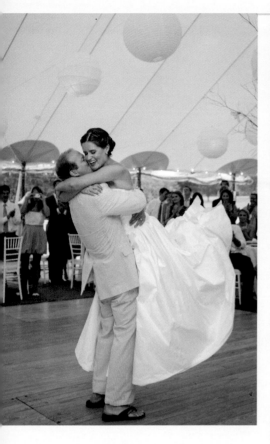

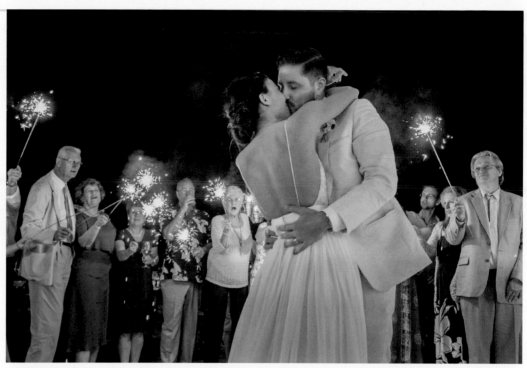

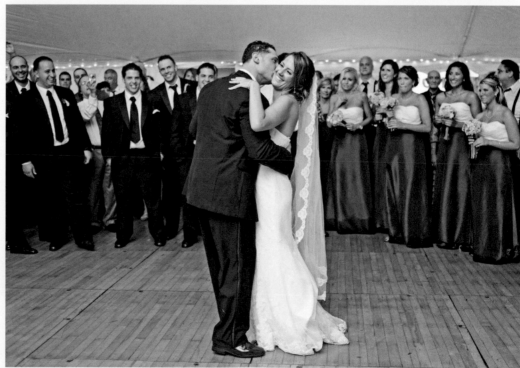

TOP LEFT
I used flash on the bride and groom during the first dance to get rid of the colorcast on their faces from the tent.

TOP RIGHT
The bride and groom planned to have sparklers during their first dance, so I was prepared to shoot this scene with all natural light (pictured) or with flash if necessary.

RIGHT
I loved the look on the faces of the wedding party in the background, so I used a wide lens to capture this moment.

CUTTING THE CAKE

Whether the couple has chosen a simple cake, an elaborate cake, or even cupcakes, I always photograph the cake at some point during the reception before the bride and groom cut it.

I like to do so earlier in the evening so that I can photograph it with ambient light (many receptions tend to get darker as they progress), but there are times when the cake isn't displayed until right before the cake-cutting.

Pay attention to the details on the cake. Some cakes are designed to match the color scheme of the wedding, some have patterns of icing to match the flowers, and some will be elaborately decorated with custom cake-toppers that have been made to look like the bride and groom, or to reflect their individual interests.

You never know what kind of cake-cutting you are going to get. I have had the most reserved couples chase each other around the reception with the cake and the most rowdy couples gently feed each other at the same time. While most of my couples fall within the latter group, I am prepared for either scenario. The cake-cutting is also a great opportunity to capture some of the other important players at the wedding—you can get a great shot of the mother of the bride smiling at her daughter with the groom in the background if you angle yourself properly. It is also fun to capture all of the other cameras that are at the reception. Most of the guests will congregate with their own cameras to take photographs of the bride and groom cutting the cake and I love to swing around to the other side of the bride and groom to photograph them in the foreground with all of the cameras in the background.

BOTTOM LEFT
Look for great expressions in the background!

BOTTOM RIGHT
Try to capture the cake before it is cut.

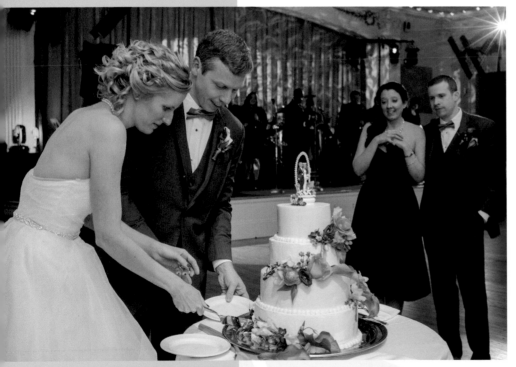

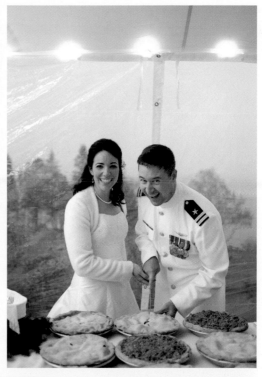

TOP LEFT
I like to photograph a detail shot of the topper in addition to an image of the entire cake.

TOP RIGHT
This bride and groom chose pie over cake for their wedding day.

RIGHT
I wanted to capture the beautifully lit venue in the background, so I balanced flash on the brides with ambient light.

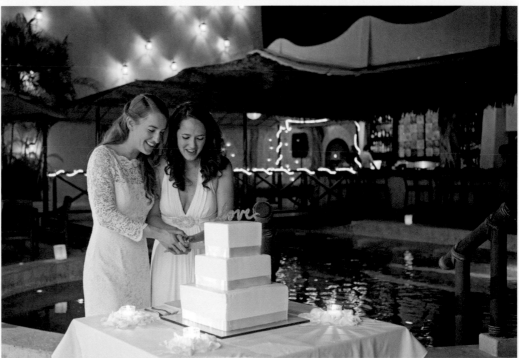

OTHER EVENTS

I always check with the bride and groom to see whether they have any other events planned for the reception. At many Jewish wedding receptions, for example, they will dance the hora. At some Mexican weddings, the guests pin money on the bride and groom's clothes while they are dancing.

Some of my more free-spirited couples will buck tradition entirely and avoid scheduled events altogether, making it imperative that you keep a lookout for natural interactions between the bride and the groom and their families and friends.

You should be doing this anyway, of course, but there is more pressure to photograph the bride and her dad sharing a candid moment when they choose to forgo the father-daughter dance. Although less common now, some brides and grooms still opt to do a bouquet and garter toss. Some couples choose to honor the other couples present who have been married for decades with an anniversary dance. This will give you a great opportunity to photograph the various couples dancing together.

I have seen many other special events as well—karaoke performed by some of the guests, a lip sync performed by the bridesmaids, fire juggling, belly dancing, fireworks, poems that the bride and groom read for their parents—really, there is no limit to what may happen during the reception. Most of these special events are planned, but some are impromptu. If I am taking a break to eat, I try to remain in earshot of the reception so that I can hear any last-minute plans. It is always a good idea to get off on the right foot with the DJ or MC, as they will usually be the one who is asked to coordinate any changes to the schedule and they will alert you if you ask. The maid of honor and the best man are also good resources, as is the event planner or coordinator. These people are usually in the thick of anything being plotted for the reception.

BELOW
Digital cameras let you capture images at a very high ISO but they don't give you much dynamic range at the highest settings. Lanterns are tricky against a dark sky, so make sure you are watching for overexposure on the faces. I generally try to meter using the face of my subject.

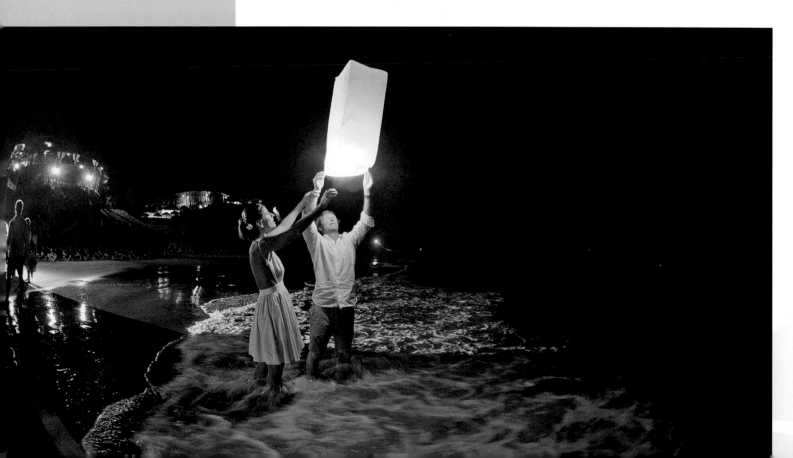

ABOVE
Fire jugglers are a fun addition at many tropical weddings.

TOP LEFT
I used off-camera flash to light the face of the groom and provide rim light during this piñata shot.

RIGHT
It poured during the time that we planned to go to the beach for portraits, so the bride and groom went bowling instead!

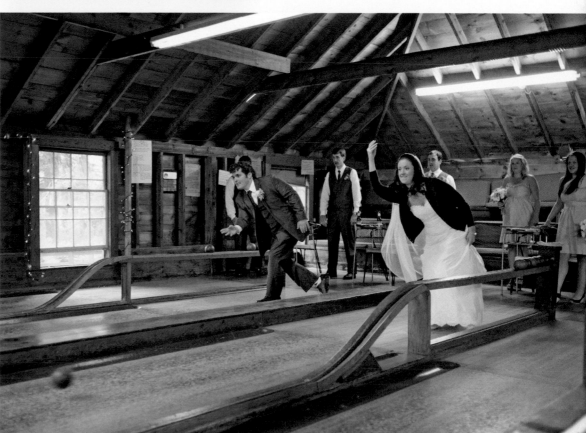

OPEN DANCING

It is during the open dancing that I feel I can capture the spirit of the reception. Some are loud, raucous affairs, while others are quiet and tame.

First, I make sure that I photograph the musicians if they have chosen to hire a band. Second, I try to capture as many different guests dancing as possible. Third, I always try to capture the parents of the bride and groom, the grandparents of the bride and groom, and the wedding party on the dance floor. Although I do try to capture everyone, I will spend more time focusing on these people during the reception.

If there is a balcony or stage of some sort in the reception room, I use it to get some elevation in order to shoot down on the reception. If not, I will often just walk around the dance floor with a wide-angle lens. I usually get right in the middle of the dancing, and although it means that I occasionally get jostled around, it also means that I am going to have a fabulous time because I am right in the action. Once the first dances are over, I generally switch to a focal length between 8mm and 35mm. I carry one camera with a mild fisheye (allowing me to get right in the middle of the dancing) and one camera with a lens in the 20–35mm range.

Make sure that you acquaint yourself with the focusing modes on your camera. The mode that you use throughout the day is sometimes not the best mode for tracking fast-moving subjects in the dark. All camera models handle it a bit differently (with varying degrees of success, especially depending on the focusing speed of your lens), so really get to know your camera and lenses in the dark before you photograph the live action at a wedding. If my lenses are struggling to focus, then I'll switch to manual focus and stop down enough so that I know my subjects will fall within my deep depth of field.

I like to leave my flash off when I can for the first dances, but as it gets darker I'll start to rely more on my flash setups. I typically use a two- to three-light setup—with two lights off camera and a third on or near my camera for fill light. I also like to use a trigger that allows me to turn one or both off-camera flashes off directly from my camera. That way I can change the mood created by the light without tearing down my light stands. For more information on the equipment that I use, check out the sections on Lighting a Room (pages 46–49) and Light Shaping (pages 16–17).

RIGHT
I often use a wide-angle lens once the open dancing starts. It gives distortion at the edges of the frame, but during the crazy end of the night, I don't mind it.

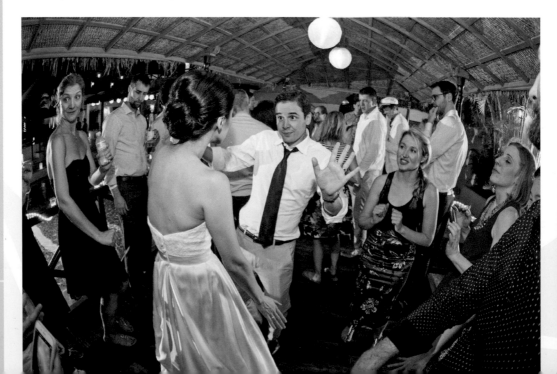

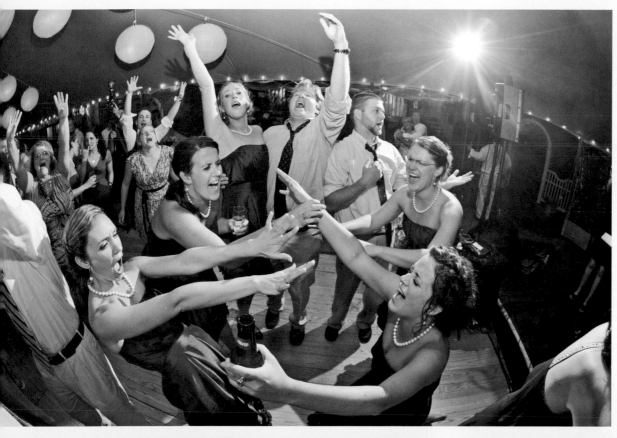

LEFT

Sometimes shooting from above can be a great way to get a lot of people in the frame together. I'm not very tall, so I'll frequently hold the camera overhead.

BOTTOM MIDDLE

I often use flash to help me stop motion during the open dancing.

BOTTOM RIGHT

If the dance floor is in a gorgeous spot, I like to take a wide image of it and include the light and surrounding area.

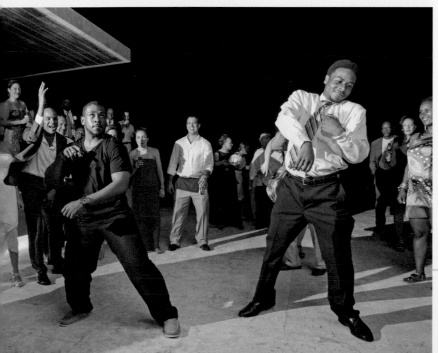

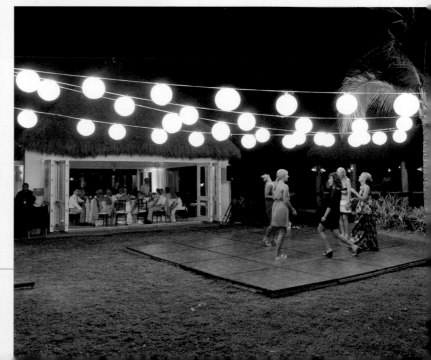

THE SEND OFF

Sometimes the bride and groom will organize an elaborate send-off themselves, and sometimes the send-off will be a surprise gift from parents or friends. It might be a last dance, a decorated getaway car, or something that requires more planning and effort.

The most common special send-offs that I have photographed have involved vintage cars, fireworks, and sparklers (thankfully, not all at the same time).

The sparkler send-off is a fun way to photograph the bride and groom as they leave the reception. Usually, the guests have been lined up with sparklers lighting the way as the bride and groom run through the aisle they have left between them. I like to photograph these with ambient light alone and use a touch of fill flash if the light from the sparklers isn't sufficient to bring up the shadows in the bride and groom's faces.

Fireworks are a bit more tricky, as it can be difficult to get the bride, groom, and fireworks in the same frame. If possible, I try to have the bride and groom elevate themselves—stand on chairs or on a low wall—while I crouch down or even lie on the ground and shoot up at them. (See the section on Fireworks on pages 56–57 for more information.)

If the bride and groom have a special last dance, this is usually a better time to photograph them than the first dance. They usually cuddle together and the guests are not afraid to crowd in even closer than they were during the first dance, and this gives me a chance to photograph the bride and groom in an embrace surrounded by their close family and friends.

I like to be creative when I light the getaway, and have been known to use the headlights from one car to illuminate a sparkler exit or even the getaway car of the bride and groom. Video lights are also fabulous in this situation because they produce a constant source of light and are easy to manipulate.

RIGHT
When I shot this series, I was shooting with off-camera flash on one camera and natural light on the other. I'll frequently set up one camera for each, and that will help me prepare for any scenario.

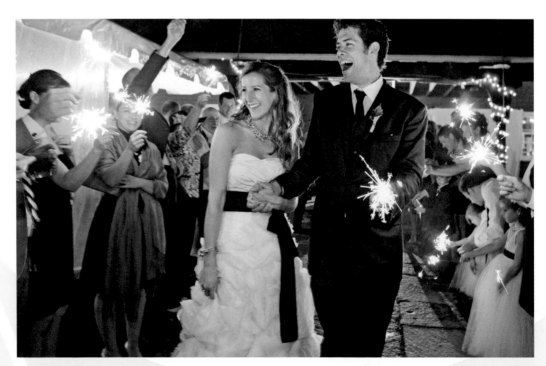

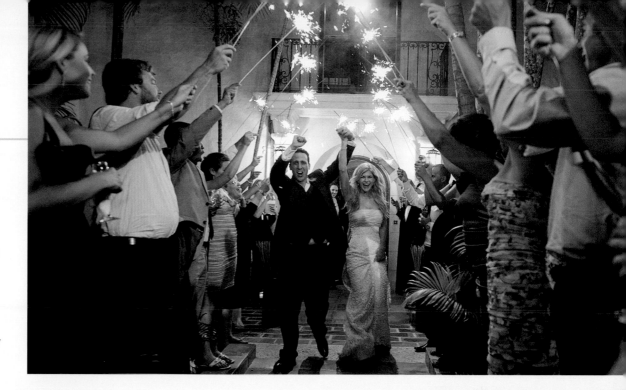

RIGHT

During sparkler exits, I like to position myself at the end of the line, right in the middle of the path. Make sure that you watch the sparklers around you before you move.

BELOW

Find out if the bride and groom have a getaway vehicle so that you can photograph any decorations on it.

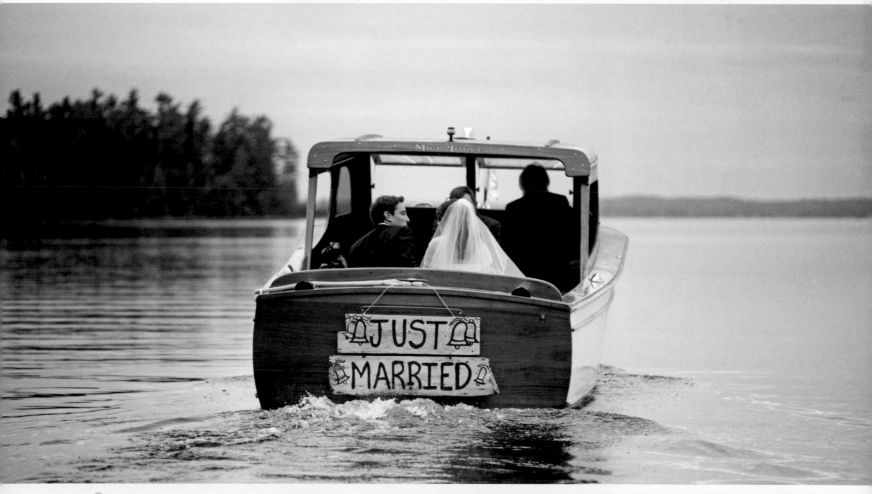

REAL WEDDINGS 1:
EMILY & GRAHAM

Emily and Graham were married on the coast of Maine near Acadia National Park. They worked with a wonderful event designer (Maine Season Events) to achieve their vision for the day.

The theme incorporated beautiful soft colors that blended perfectly with the harbor location, and the tent design combined luxury and elegance with the beauty of an outdoor wedding.

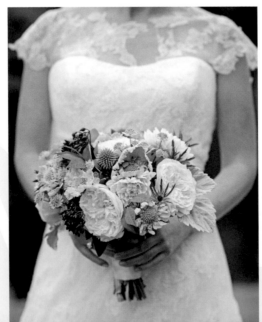

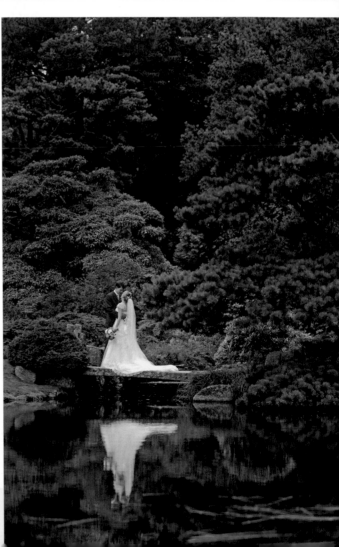

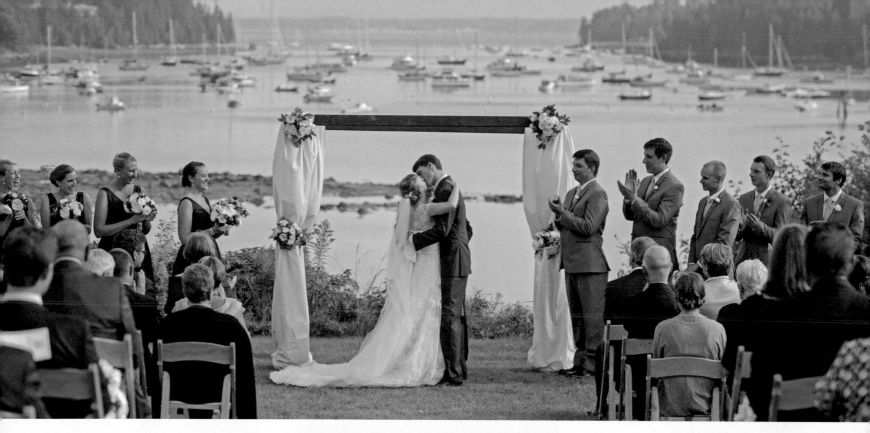

REAL WEDDINGS 2: LAURIE & CHRIS

Laurie and Chris chose a villa on the Pacific coast of Mexico for their New Year's Eve wedding.

The food was beautifully presented (and was very important to the couple), so I made sure to communicate with the caterer (Plush) prior to the event to ensure that I would have time to photograph it. Laurie and Chris also had several special events throughout the evening, from sparklers to fireworks, and since these events were all surprises for the guests, knowing the schedule ahead of time was key.

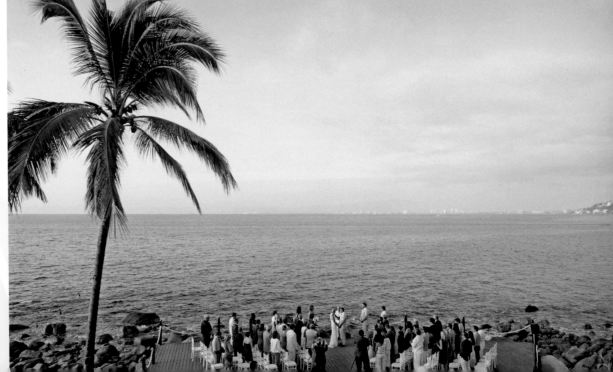

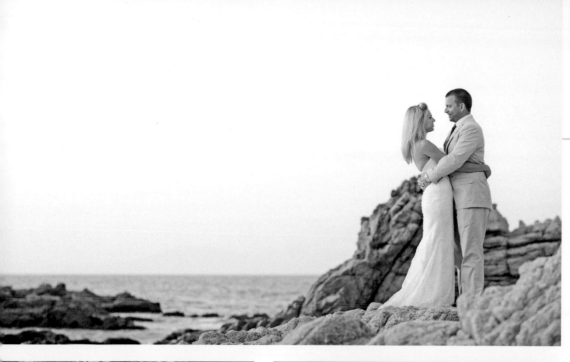
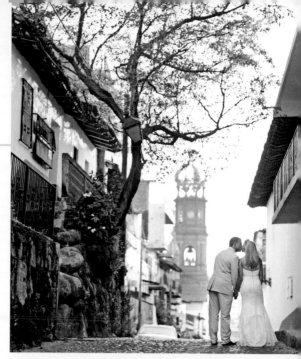

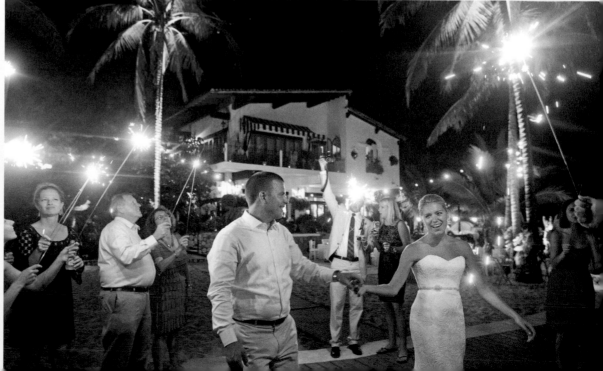

REAL WEDDINGS 3:
EMILY & KEVIN

Emily and Kevin were married on Martha's Vineyard, an island in Massachusetts. They chose the island as they had both summered there at their family homes during their youth, so the location was a special one for both of them.

They were married in a church and then held their reception at The Field Club. We took the time in between the ceremony and reception to head to the beach to take some images of the two of them.

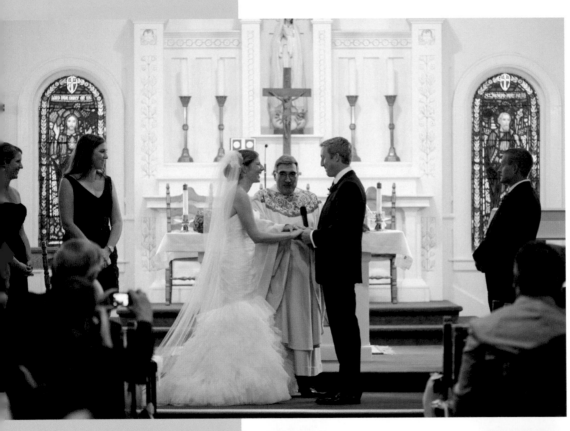

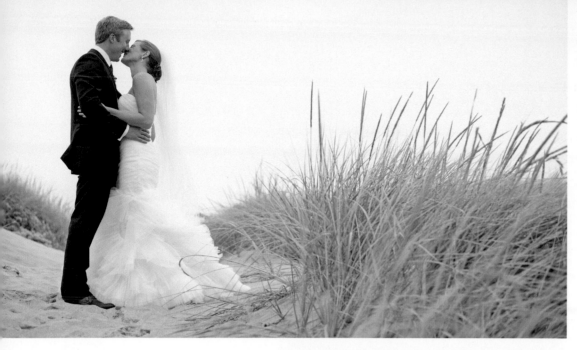

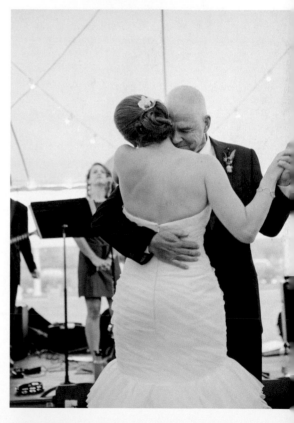
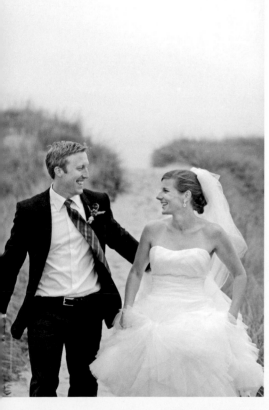
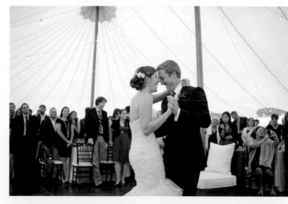

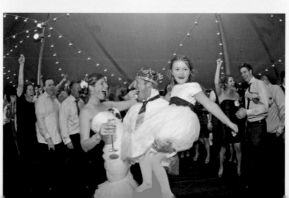

REAL WEDDINGS 4: SONYA & LUCAS

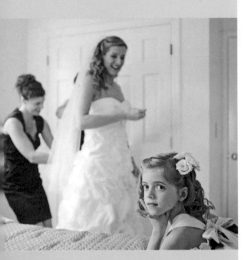

Sonya and Lucas were married at the Camden Yacht Club in Maine and then chose to take a boat from the ceremony to the reception. If the couple chooses a special form of transportation and I'm working by myself, I'll find out in advance whether they'd like me to be on the boat with them or capture their arrival from afar.

If we want to capture both, then I'll ride on the boat with them and have them drop me off so the boat can loop back around for an "official" arrival. They incorporated soft pinks and navy stripes in their details, with a beautiful nautical theme that perfectly matched the venue.

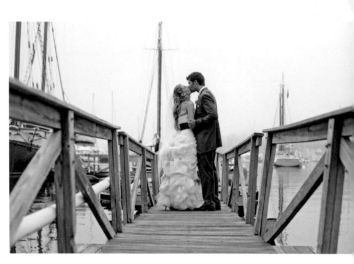

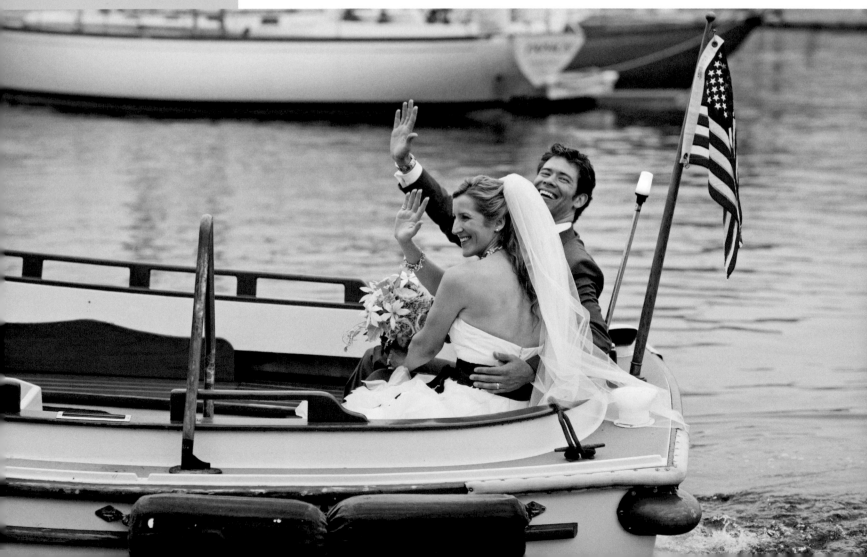

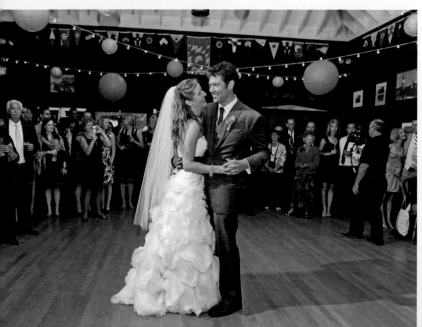
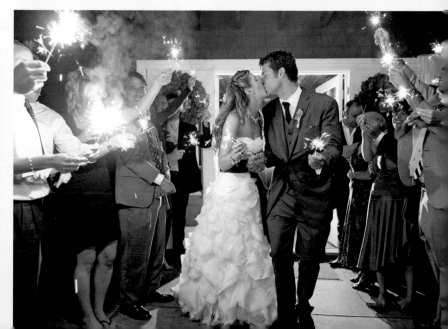

REAL WEDDINGS 5: JEN & MIKE

Jen and Mike chose a beautiful private villa in Mexico for their wedding. They worked with the Dazzling Details to organize everything from the beautifully designed decor to the first dance lit by sparklers.

The café lighting around the lawn provided enough ambient light to shoot with just natural light outside, but once the party progressed into the villa for the dancing I supplemented the ambient light with some of my own.

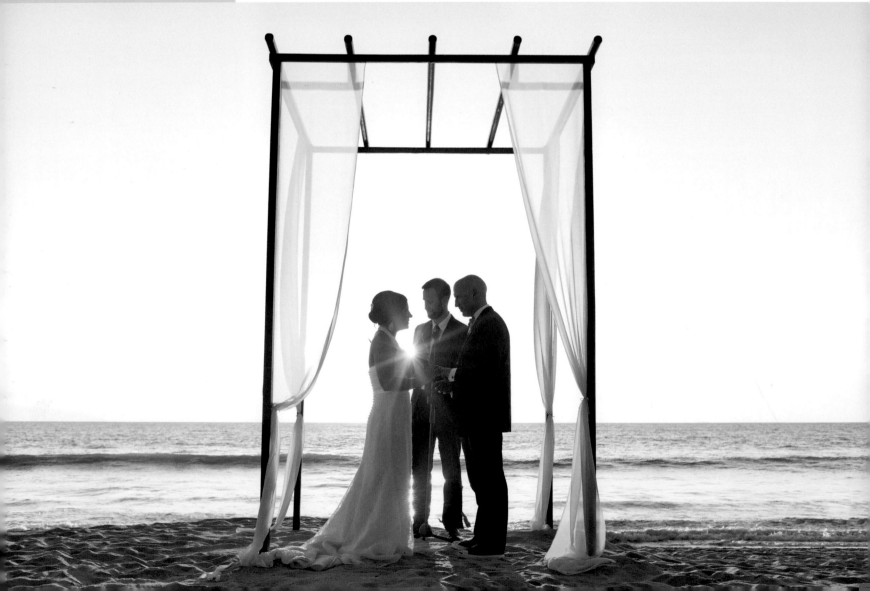

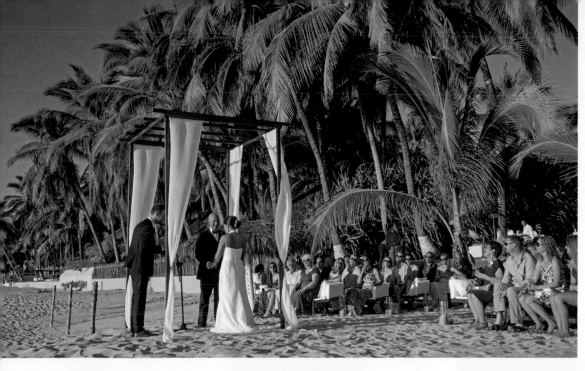

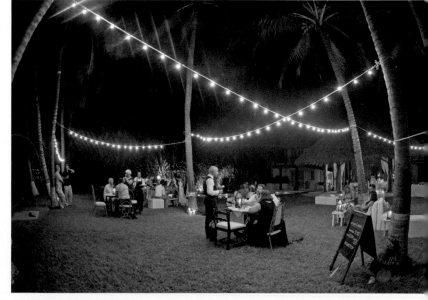
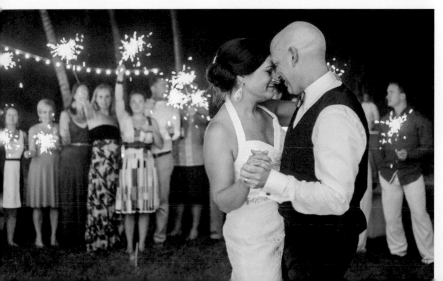
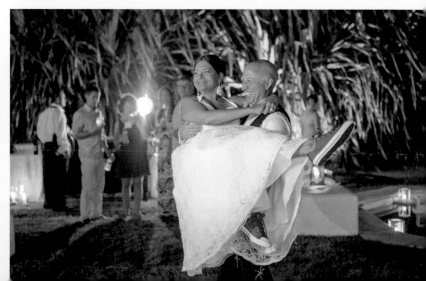

REAL WEDDINGS 6: JENNA & TUCKER

Jenna and Tucker held their reception at Tucker's family farm on the New England coast, and the design incorporated a number of beautiful touches from the bride, the groom, and their families.

They married in a small community chapel and then headed back to a gorgeous tent that was set up to overlook the water.

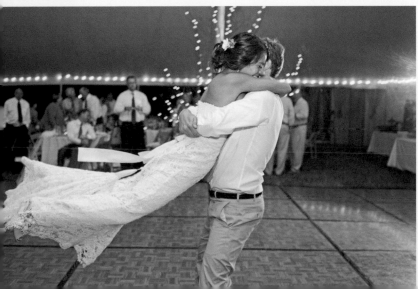
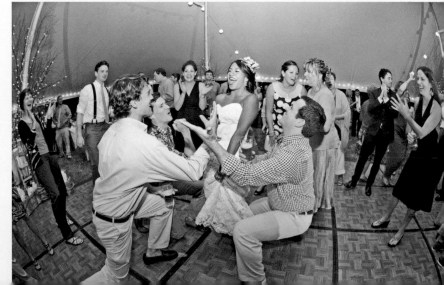

REAL WEDDINGS 7: LINDSAY & CHRIS

Lindsay and Chris were married at a villa on the Pacific coast. The design of the reception was incredibly important for both of them, so I made sure to work with the designer to schedule extra time to photograph the setup before the guests arrived.

If I'm photographing specific details early in the day (when the sun is high in the sky and shadows are very visible), I'll be sure to loop back around and capture some of the same details again when the sun drops and the light gets prettier in the evening.

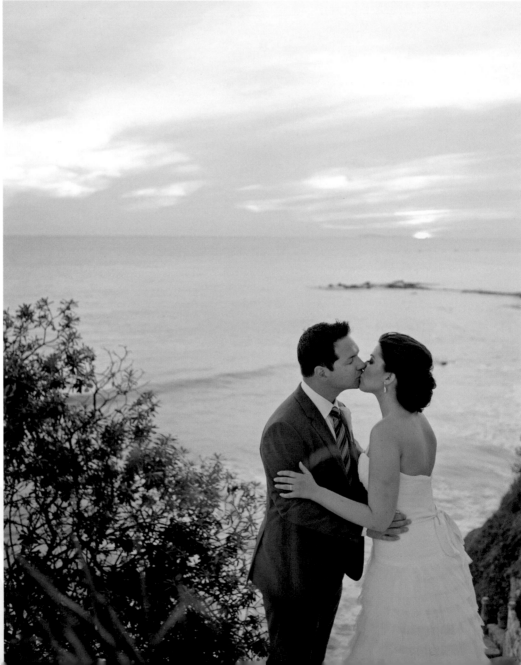

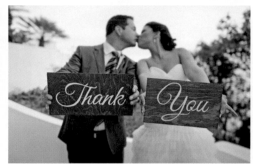
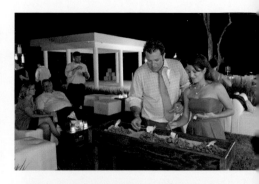
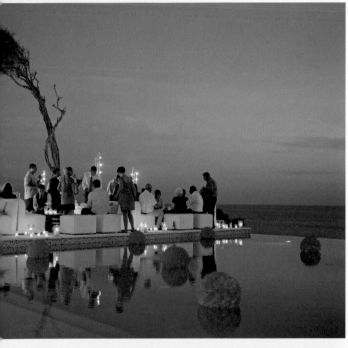

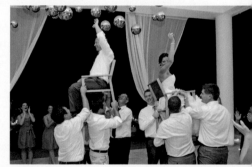
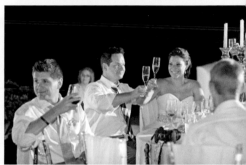
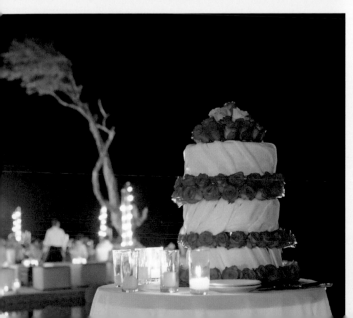
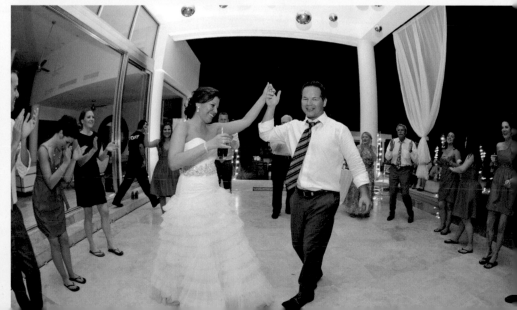

REAL WEDDINGS 8: DANA & BRIAN

Dana and Brian were married at the lovely retreat at French's Point in Maine. It is one of my favorite venues, and I love the fact that ceremony and reception are all in one spot. The forecast was threatening rain, so when it did start sprinkling the couple were prepared with gorgeous clear umbrellas.

We were lucky to have a beautiful rainbow after the rain, and even though the couple were in the middle of dinner I was able to grab them for a few shots with the rainbow in the background.

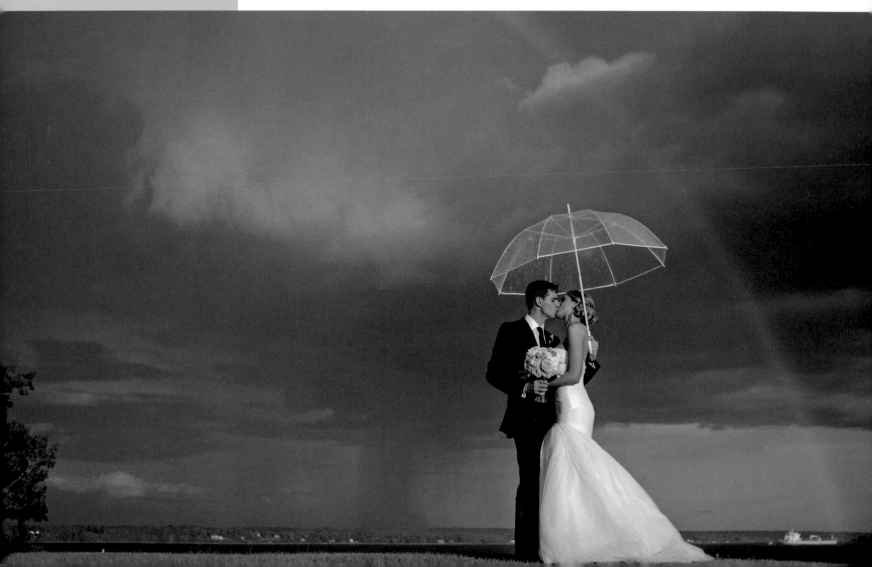

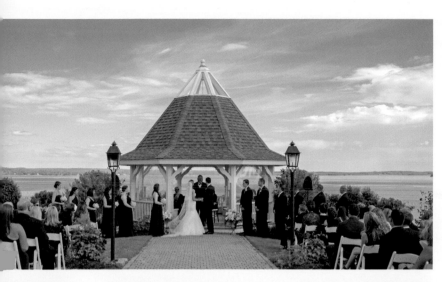
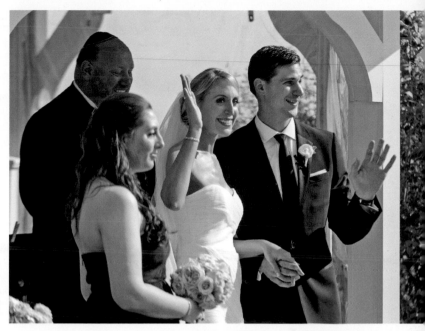

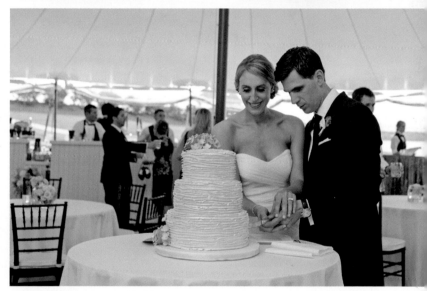
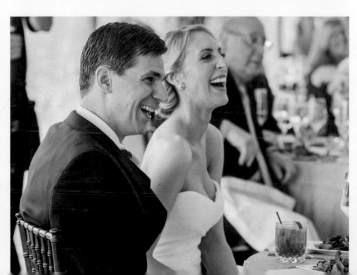
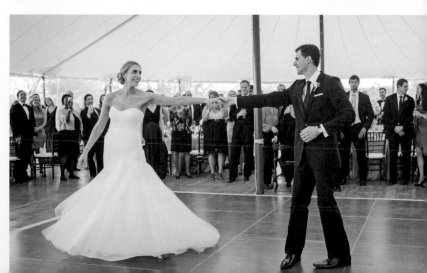

THE POST SHOOT

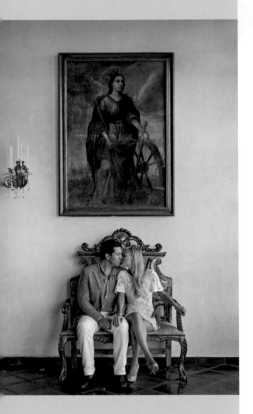

ABOVE
The bride chose to wear a different dress for the day after her wedding as we traveled around town for the post shoot.

RIGHT
This couple chose to end their post shoot in the water. I left one camera and most of my gear on land while I was in the water with them just in case we were surprised by a wave.

I love being commissioned by the bride and groom to shoot a "day-after" session. This gives the couple a chance to get dressed up (often in the wedding dress and suit again), so they look beautiful together, but they do not have the pressures of the wedding day.

There are no time constraints, reception details, or guests to worry about. The day has come and gone, and they are completely relaxed.

By this time, of course, they are completely comfortable with me and they aren't afraid to be openly affectionate with one another. We've developed a great rapport. The bride is also not afraid of getting the dress a little dirty, so we can choose a location that is a little grittier or, occasionally, we can even get the dress wet. Sometimes the bride and groom choose to adopt a completely different look for their post shoot and will wear something different as we traipse around town. I'll even photograph "destination" post shoots, which are in a completely different city or country from the original wedding but are at a location that is equally special to the bride and groom.

For the day-after shoot, I either try to find different, interesting locations for our session or I may simply use locations from the day before that we didn't have time to get to. Say, for example, that the bride and groom are having their wedding in a coastal town, but not right on the beach, and there simply is not enough time to get there and get back to the reception in the timeframe that they have allotted. If this is the case, I will recommend a day-after session. It usually lasts about two hours and we drive to several different interesting locations.

Although the beach is the most common request for these sessions, I have also done some fabulous urban sessions—lots of back alleys, forgotten side streets, and well-known landmarks. I generally find out what the bride and groom are looking for prior to the post shoot—it's important for me to know whether they want to get wet, since I may think differently about the gear that I bring on location with me. If you are getting into the water yourself so that you can shoot it in the foreground, keep an eye on the waves so that you don't get your equipment wet. Even though I'm typically a two-camera shooter, I'll only take one camera and one lens in the water with me so that I'm only worrying about the gear that is eye level, rather than anything hanging around my waist.

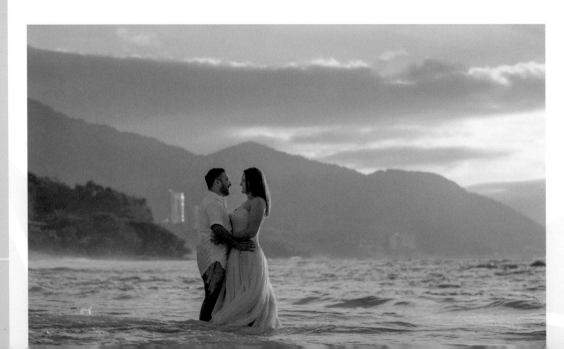

We headed into town the day after the wedding in the Dominican Republic to capture some of the color and beautiful beaches. Both were very different from the venue where they held their ceremony.

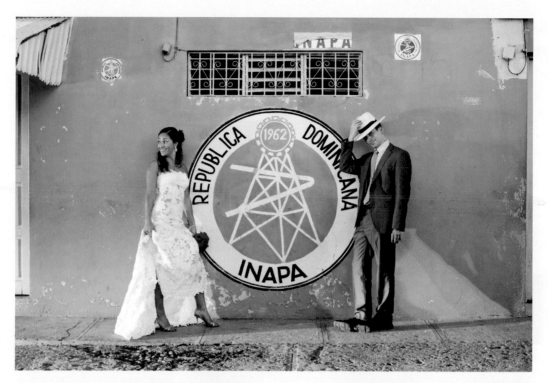

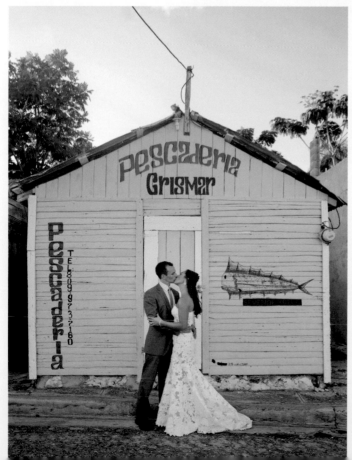

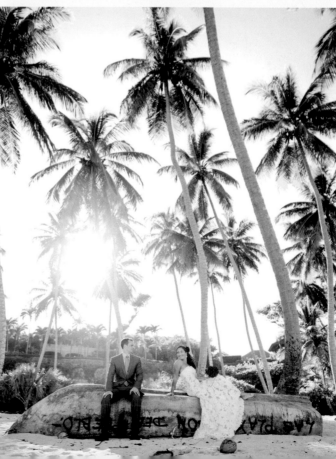

The wedding day

POST SHOOT 1: CARNI & DEMAN

I photographed Carni and Deman in Paris. They chose outfits that were fun and fit the fashionable urban nature of the shoot. There are so many locations to consider in a place like Paris, so we tried to combine some of the more famous locations with some lesser-known spots.

I spent the day prior to the shoot scouting around to ensure that I knew which locations I wanted to visit in different types of light. I wanted to capture the Louvre lit up after dark, so we planned our schedule accordingly to allow for a late night arrival at that spot.

BELOW
I combined off-camera flash and ambient light to capture this image after dark at the Louvre Museum.

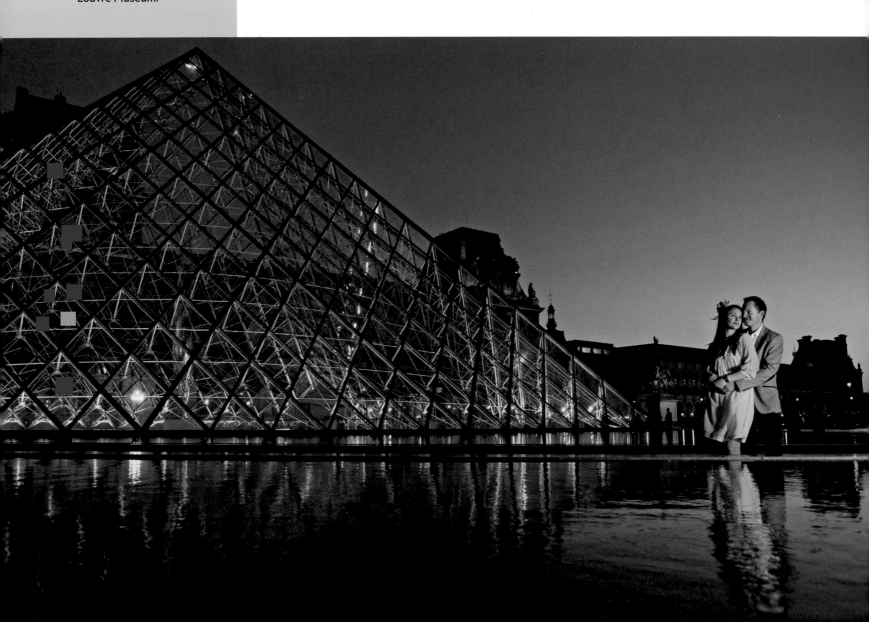

TOP
Couples will generally open up and become more playful during the post shoot.

BOTTOM LEFT, MIDDLE, RIGHT
I used off-camera flash in all three of these images to help me freeze motion, blend a background exposure with an exposure on my couple, and minimize distracting passersby.

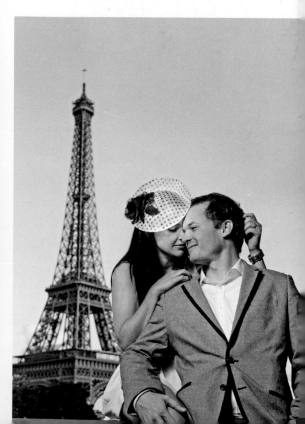

POST SHOOT 2: JEN & AMIR

Jen and Amir were married on the coast of Puerto Rico, but the spot that they chose for their wedding (although beautiful) wasn't particularly colorful.

We scheduled some time to head into Old San Juan in order to ensure that we were able to incorporate some of the gorgeous colors of Puerto Rico into their images.

BELOW
Don't forget to grab the stolen moments as you travel from spot to spot.

RIGHT
Occasionally the bride and groom will bring props so they can take a photograph for their thank you card.

RIGHT
I loved the look of the silhouette in the image in Old San Juan.

BOTTOM LEFT
I knew I wanted to use that window as a framing device the moment I saw it.

BOTTOM MIDDLE
I loved this bright blue wall as a background for the bride.

BOTTOM RIGHT
The cobblestone streets are as indicative of the area of San Juan that we were in as the colorful walls, so I incorporated them into several images.

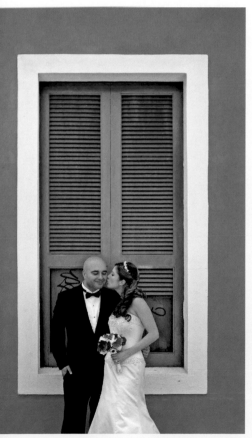

4 POST-PRODUCTION

ORGANIZATION AND VISION are key elements when you are creating a solid post-processing workflow. You never want to have to explain to a client that you lost their images or saved them as web-sized only. You also don't want to spend days watching spinning wheels as you try to process thousands of images either. Remember that the closer to perfect that you can get the images in camera, the less time you'll need to spend in front of the computer. The best images happen before you even take the photograph, and many issues (under or overexposure, composition and/or framing issues, distracting foreground/background elements, bad poses) are best fixed in-camera on the day of the wedding, so don't forget to scan your images and check your exposure via histogram (since your camera's LCD can be deceiving as you look at it in different types of light).

First, know what you are trying to accomplish with your images and go into the processing stage with a consistent style. Remember that many post-processing tasks can be done in batches, and that will speed up your workflow considerably. Identify images that need some TLC or that may be portfolio images that could be improved with some extra time in post-processing. My goal is to deliver an entire gallery with hundreds of print-ready images to my clients, but I also deliver a handful of images (approximately 30) that I have worked on a bit more.

RIGHT
A careful exposure on the wedding day was essential when it came to post-processing this image. I needed to ensure that I neither underexposed and blocked my shadows (which would introduce a great deal of digital noise in the post-processing stage) nor overexposed and blew out my highlights on the couple (which are difficult if not impossible to recover successfully).

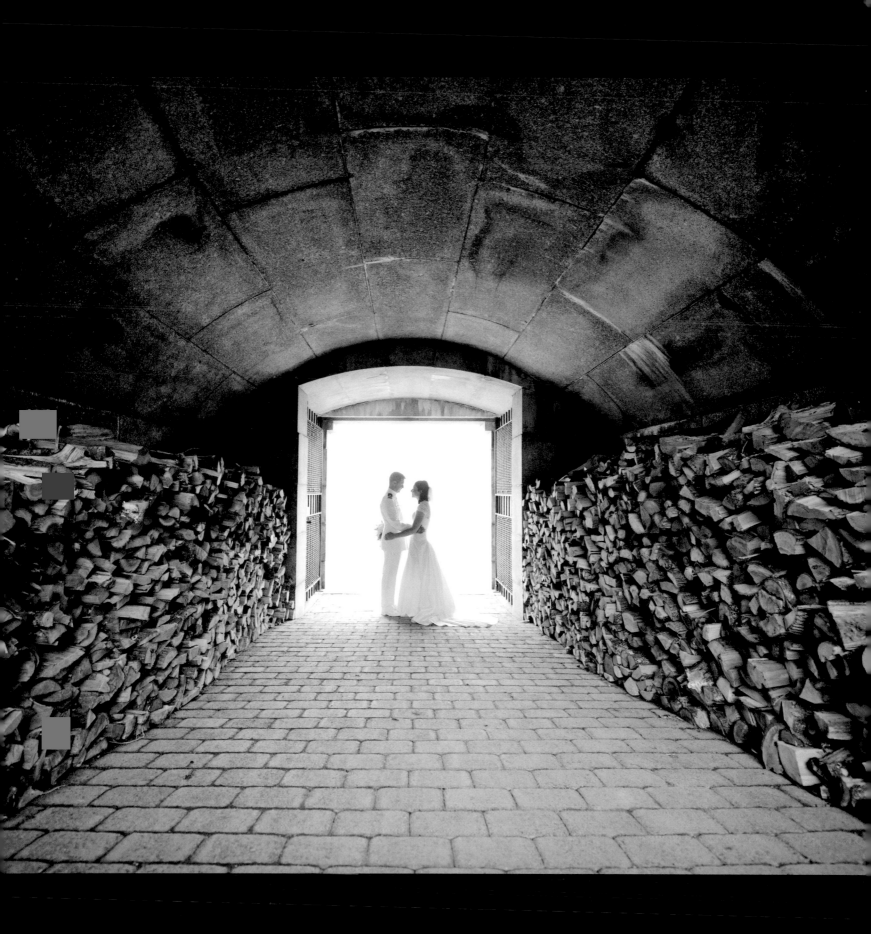

WORKFLOW

You finished shooting the wedding and you have 3,000 Raw images. How do you take those and sculpt them into polished photographs? Here is where the post-production phase of the wedding begins.

In general, I spend almost as much time in post-production (from backing up the images to the album design) as I do shooting the wedding itself. It is essential to have a good system in place for handling your images after the wedding and taking them through to the delivery stage. Over the years, I have tweaked the details of my workflow and am now down to this checklist of steps for myself:

1. Download the wedding images immediately to my HyperDrive ColorSpace storage device on my way home from the wedding. It is an incredibly quick and efficient way to make a second copy of all of my images and to bring all of them into one place.

2. Keep the memory cards off-site (so that I have multiple copies of the images in different locations) and bring the ColorSpace device into the office to put the images onto my computer for processing.

3. Back up the Raw images to the client file on an external hard drive and name the file in the "YYYYMMDDNameName" format. For example, if Sara and Chris were married on December 31, 2016, their file name would be "20161231SaraChris." By naming the folder in this fashion I ensure that I can find the images by date or by name and that my storage devices will sort them in the order in which they were photographed.

4. Import the images into Lightroom, and apply my own preset. Also create Smart Previews so that I can work on the images while I'm not hooked up to my hard drive.

5. Create a "sneak peek." I choose a handful of detail photographs mixed with some of my favorite environmental portraits of the client, as well as any stand out moments from the ceremony and reception, export these images, retouch them in Photoshop, and create a blog composite in Photoshop.

6. Cull the images in Lightroom.

7. Lightly edit the images in Lightroom (color-correct, adjust exposure).

8. Export the images as high-resolution JPEGs.

9. Combine the exported images with the high-resolution blog edits and create the finished folder of images. Rename the images in Bridge.

10. Copy the folder to two hard drives (one of which is stored off-site).

11. Upload the images to an online gallery.

12. Upload the high-resolution images for online backup and delivery to the client.

13. Format the memory cards used for the shoot and return them to the pool of cards.

By sticking to this workflow, I am able to ensure that I have followed each and every step. I can relax knowing that the images are safe and that even if disaster strikes my home office or I suffer a hard-drive failure (this has happened several times over the course of my career), the images are in more than one location. I used to have a big, dry-erase board in my office and I would log all of my weddings on there, but now I have developed a checklist on Numbers for the iPad that allows me to see all of my tasks across every outstanding job at once.

OPPOSITE
A proper post-production workflow may seem fastidious and redundant—because it is. That's the whole point. There's no second chance to catch intimate moments like this, so make sure your images are thoroughly backed up.

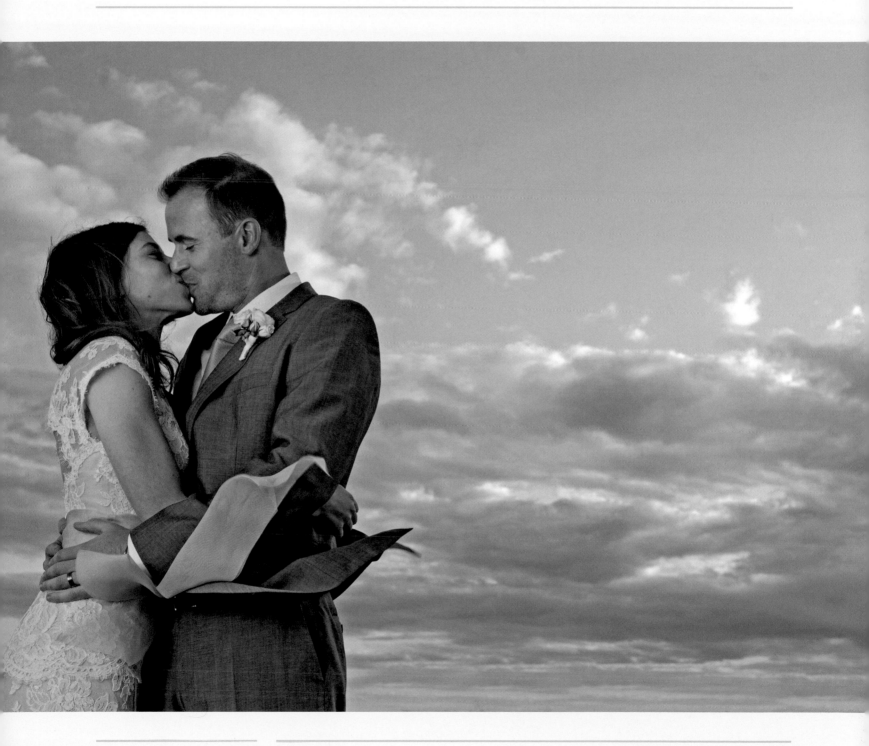

Post-production

IMPORTING, SORTING, & CULLING IN LIGHTROOM

I use Adobe Lightroom for the majority of my post-production. It is a fantastic tool for processing images. Not only does it allow you to maintain and organize a large library of files, but it also lets you process Raw files alongside JPEG files and make area-specific adjustments.

In fact, only a handful of images ever make it into Photoshop and I find that I can accomplish most of what I want to do right in Lightroom.

First, I import the chosen folder of images into Lightroom. As I import the images I apply a custom preset (this setting is available in the import dialog). This custom preset includes a camera specific setting (I choose the Profile that I'd like under the Camera Calibration panel in the Develop module) and then I tweak it by adjusting the shadows and the highlights. I also ask Lightroom to render Smart Previews so that when it comes to the editing stage, having these previews already generated

will speed up my workflow exponentially. If you forget to do it at the import stage however, you can build the previews by selecting all of the images and going to Library > Previews > Build Smart Previews while you are in the Grid Mode (select Library on the upper right or press G).

When you are in Grid mode you can also sort the images by Capture Time (in Grid mode, go to View > Sort > Capture Time). Prior to every shoot, I sync the time of my cameras, as over the course of a week they will stray from each other by a few seconds, and I want the ordering process in Lightroom to be seamless. If your cameras are lined up, then when you ask Lightroom to sort your images by capture time it will display the images sequentially in the catalog. It is possible to change the time stamp on the images from one camera if you forget to sync your cameras prior to the shoot, but it is much simpler if you remember to do it from the outset.

BELOW & OPPOSITE
Adobe Lightroom makes it easy to create keyword batches for individual images on import. Go to the right side of the screen, open the "Apply During Import" dialog, and type in your keywords.

Post-production

I use the Library mode (pictured here) to "edit in" or "edit out." To "edit out" (my preferred method for weddings), I mark the images with a "rejected" flag by pressing X.

Once I have imported and renamed my images I start the culling process. I used to cull and edit in one step, but I find that I have shaved hours off of my edit time by separating the two tasks. There are two basic styles of culling: "editing out" (ditching the rejects) and "editing in" (selecting the keepers). I edit in for all of my sessions. I know other photographers who do it the other way around. Find a style that works for you and stick to it.

If you want to quickly edit out, go to Grid mode. Above the images you will see Attributes. Click on it, and select the center flag. By doing that, Lightroom will only display the unflagged photos. That means that when you mark an image as a reject (you can do this while pressing the X key), it will disappear from the catalog (although it doesn't erase it, so you can always go back and unflag it). This is a nice feature because, if you reject a photo, it will disappear and Lightroom will auto-advance you to the next photo for consideration. It will also give you an accurate count of the images currently in your "keeper" pile. When editing out, I like to view the images full-screen, so I press the space bar to have the image fill the viewing area. If I want to keep it, I advance to the next photo with the right arrow key. If I want to reject the

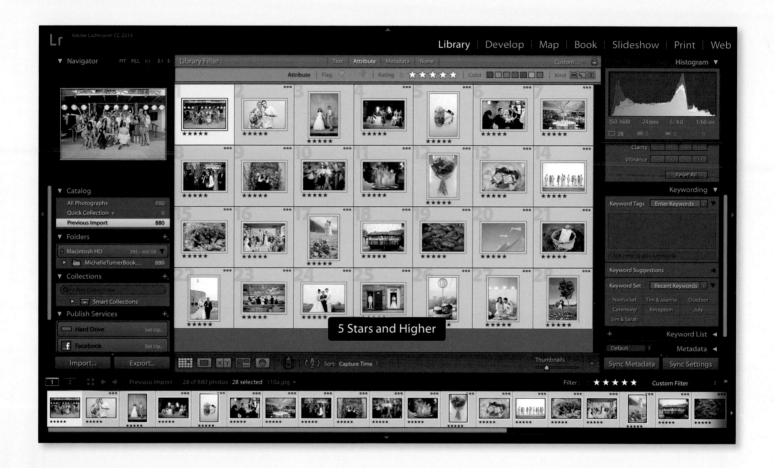

5 Stars and Higher

photo, I press X and the photo will disappear and the next photo will fill the screen.

If you want to edit in Lightroom, then you'll do the opposite. You'll go through each image and press P for the images that you'd like to keep. At the end of the process, you'll ask Lightroom to only show you the Picks (the flagged images) and you can take a look at all of the images that you've selected. I find that I can fly through the culling process in about 1½–2 hours, depending on the original number of images. The temptation to fiddle with the images is there, of course, but I resist it in the name of streamlining my workflow.

ABOVE

Once you've gone through and rated your shots, you can click the Attribute tab at the top of the Library screen to filter your results. Here I've set it to display only images with five stars. When it comes time to edit, I find it's best to start with the best and work your way down through the rest.

EDITING IN LIGHTROOM

After I have narrowed down my images into a keeper pile, I begin my editing process. I have used Adobe Lightroom since the very first beta, so I am extremely quick and comfortable with the program.

I really need to stress here that I do my best to get the images as close to perfect as I can in-camera. This is why I shoot in Manual with a custom white balance (or a white balance that I've chosen using Kelvin).

This is also one of the reasons why I love using off-camera flash during the reception. My exposures are very consistent from shot to shot, and this is essential for me in the editing stage. I don't want to spend any more time than I need to on the computer, and the closer I get my images to where I want them in the shooting stage, the less time I have to spend after the fact adjusting them.

One of the great things about Lightroom, of course, is that you can batch-edit. If I find that my white balance or exposure was a little off, it's generally off by the same amount for an entire series of images since I am shooting in Manual. So, I'll make the adjustments on the first image and then batch-edit the rest in that series to match the changes that I made on the first. This really speeds up my workflow significantly.

Using Develop Settings and Profiles Specific to Your Camera: I like a clean editing style and I love the look of the Fujifilm files straight out of the camera. Fujifilm (like many camera companies) gives you the ability to customize the look of your files. I choose the Provia/Standard setting for most of my images, and I find that gives me beautiful color. I've created a preset to apply the Provia/Standard setting. You'll find the specific options for your own camera in the Develop Module by selecting the Camera Calibration panel and then making a selection in the Profile dropdown. I've created a custom preset that applies the Provia setting as well as adding +10 to the shadows and -10 to the highlights.

Changing the Time Stamp: As I mentioned earlier, it is easy to sync the time between my cameras if I do it before I start shooting. If I forget to do it then though, Lightroom makes it easy to change the time stamp on an image later on. If you import your images into Lightroom and notice that one of your cameras is off, first find a photograph from the out-of-sync camera and try to find a second photograph from the in-sync camera that was taken at almost the same moment. The two moments that I generally look for are the processional (as I shoot with one camera with a longer lens until the bride is halfway up the aisle and then I switch to the other with a shorter lens) or the kiss (since I try to capture the kiss with both cameras). Look at the time stamp from both photographs. In the Library module, scroll all the way down on the right menu slider to look at your metadata. If my Fujifilm X-Pro2 has the kiss happening at 12:42:15 and my Fujifilm X-T1 has the kiss happening at 12:45:20, then I would change the time stamp on one of them so that the time stamp is almost identical for both. The great thing about Lightroom is that it will change all of the other files from that camera by the same margin. Simply select all of the images taken with the X-T1 (go to the Library module, click on the Metadata Tab over the grid, choose the 1D Mark IV and then go to Edit > Select All). Make sure the kiss photograph is the image that you see in the Navigator box, as this is the one you are going to change to a specific time. Select Metadata > Edit > Capture Time. Not only will Lightroom adjust the time stamp on that file, but it will also adjust every other selected photograph by the same amount of time.

Creating a Custom Black-and-White: Go to the Develop module and scroll down on the right menu slider until you see HSL/Color/B&W. Select B&W and your photograph will be converted to a black-and-white image. Lightroom will automatically select a grayscale mix that it thinks will work for your photograph, but you can play with the sliders to tweak that

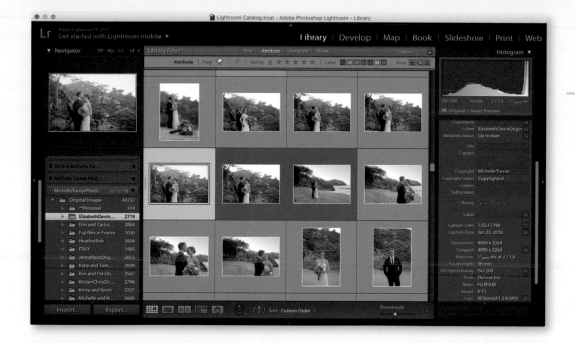

mix. I generally like to lift the skin tones, so I will move my red, orange, and yellow sliders to the right. If there is a specific tone that you want to change, select the little circle to the left of Black-and-White Mix and click it onto a part of the photograph that you want to change. Click, hold, and pull the mouse upward if you want to lift the tones, or click, hold, and drag the mouse downward if you want to deepen the tones. Make sure you are looking at the entire image when you do this. All similar tones will also be affected to the same degree. This is great for subtly deepening skies or grass in an image. When you are done, simply click the circle to the left of Black-and-White Mix a second time.

Creating and Saving a Preset: Presets are so easy to make in Lightroom. If you find yourself doing the same tasks over and over again (for example, adding +10 contrast, +10 brightness, and +20 vibrance to every photograph), or that you like a particular black-and-white mix that you have created, then make a preset for it to save you time. To do this, make the changes that you want to save to the preset to one of your photographs in the Develop module (to get there, click on Develop in the upper-right corner or simply press D) and then click on the plus sign over the presets listed in the left column of the Develop module. A dialog box will come up asking you which changes you would like to save in the preset. Click on the applicable changes, name your preset, and save it. For example, if I am saving a shadow and highlight preset, then I would tick the boxes next to shadow and highlight and then press Create. Voila! Your preset will appear in the left column and you will even be able to apply it upon import. Presets are an absolute must if you want to speed through your editing process. If you don't love the look of your camera's color, there are several other presets available (simply do an internet search for Lightroom presets). Some are free, and some are available for purchase. They run the whole gamut; some add some punch to the color, and others try to simulate the look of film. Some of the most popular "film" presets include those from VSCO and Red Leaf.

Applying Presets in Batch: Now that I have created a shadow and highlight preset, I want to apply it to a batch of images. In the Library grid, select all of the photographs to which you want to apply the preset. Then go to the right menu slider and under Saved Preset, select Shadow and Highlight (or whatever you named it). Lightroom will apply those settings to all of the selected photographs while leaving your other settings (white balance and exposure, for example) alone.

ABOVE LEFT

I run every image that I take through Lightroom—it is the program that I use for culling, Raw conversions, and minor adjustments to the images to make them print-ready.

PHOTOSHOP ESSENTIALS

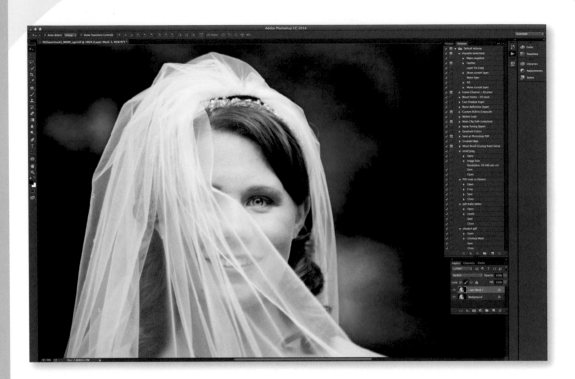

With such a great Lightroom workflow, why would I ever use Photoshop? The answer is simple: I use the programs for very different things. Lightroom is my tool for processing Raw images, while Photoshop is my tool for enhancing a handful of my favorite images that have already been processed through Lightroom.

They are programs that are used in tandem. While I color-correct and make contrast or highlight/shadow adjustments in Lightroom, I enhance colors, add overlays, and make layer-specific changes in Photoshop (including dodging, burning, and cloning). Photoshop is a truly amazing application that provides virtually limitless flexibility when enhancing and customizing your images. There are some tools within the program that can help you to polish your images very quickly and efficiently.

Actions: You can either make your own actions or purchase ready-made actions, but either way they will save you a lot of time by applying a number of adjustments to your images with one click of your mouse. To use Actions, simply open the image that you want to work on, and click and play the action that you want to apply in the Action palette. I make a lot of my own actions, but I also buy and use pre-made actions. I really like Marissa Gifford's Clean and Organic Workflow actions. They apply a number of adjustment layers to your image (warmth, brightness, depth, color, etc.), so you can tweak an image selectively using layer masks.

Keystrokes: If you make certain adjustments in Photoshop over and over again, you can assign those adjustments a keystroke. For example, I like to use the Shadow/Highlight tool to open my shadows by about 10%. Rather than clicking on Image > Adjustments > Shadow/Highlight

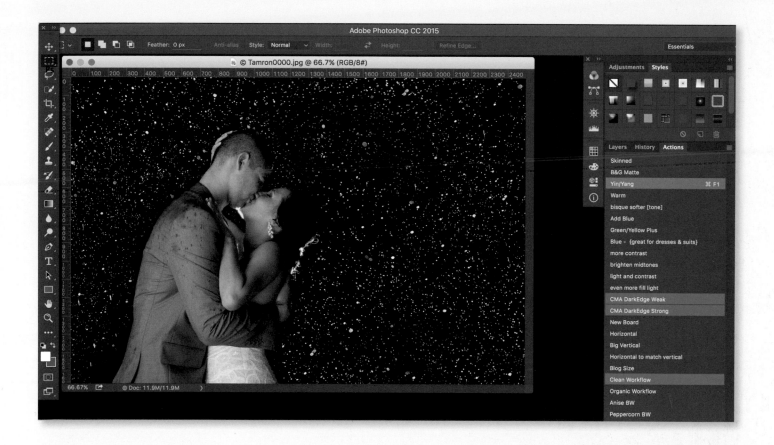

every time I want to apply this to an image, I have assigned it a keystroke. To assign keystrokes to your most-used functions, go to Edit > Keyboard Shortcuts, navigate to the menu/adjustment that you want to open and then assign it a key. You will be amazed at how much time this will save you during the editing process.

Layers and Layer Masks: Layers are great tools because they let you apply changes to an image on a separate layer. This is great for two reasons. First, you don't have to apply the changes globally across the image. Instead, you can apply changes to a small part of the image by painting the effect in or out on the layer mask. Second, if you overdo the adjustments, you can simply lower the opacity of the layer to lessen the effect or you can choose to delete the layer altogether. I always apply any image changes that I make on a new layer. To create a new layer that is a copy of your image, select Layer > New > Layer Via Copy. With that layer mask selected, you can paint on or off any effect so that it only affects a part of the image. Simply select the brush that is the opposite color of the mask (for example, if you are working with a white mask, you'll want to choose a black brush).

ABOVE & OPPOSITE

Actions can be a huge time saver, and also help keep a consistent style across multiple images—something easy to lose track of when you're deep into editing mode.

ALIEN SKIN EXPOSURE X

I love the look of old film stocks, and I use Alien Skin's Exposure X to help me achieve that look in some of my images. Alien Skin works as a standalone program or as a plug-in for Lightroom and Photoshop. I rarely use it as a standalone; I choose to access it in Photoshop.

Alien Skin is loaded with several different "stocks" that you can choose from, and you can tweak each of the settings to really make the look your own. I use Alien Skin quite a bit on the images that I bring into Photoshop. It's my favorite method for adding beautiful grain to an image. I also use it when I want to convert an image to black and white. While I can easily create a black-and-white image in Lightroom or Photoshop (and I do if I'm creating many black-and-white images at a time), I'll go into Exposure X if I want to create a really stunning black-and-white for a gallery, a sneak peek, or a print.

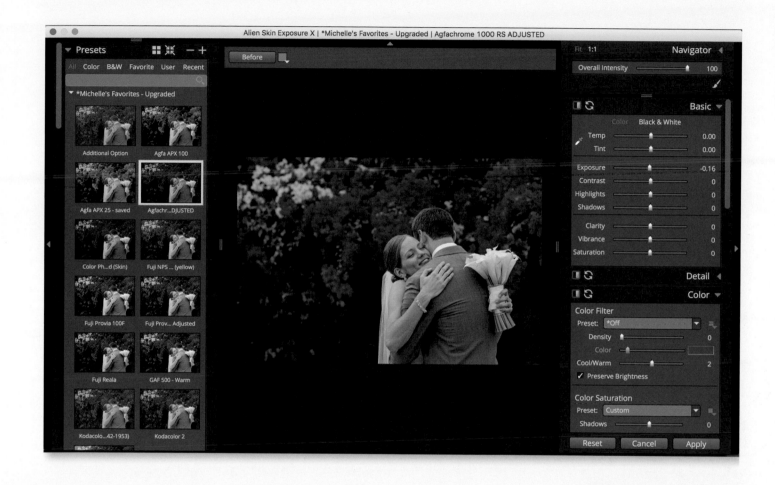

ABOVE

When used as a standalone app, Exposure X can also serve as a basic organization program, complete with flag and rating functions. It's rudimentary, but works well for small batches of images.

OUTPUT

Once you finish processing your images, you'll want to share them with the world. Some photographers showcase their images across several different online platforms, while others simply put the files on a hard drive and give it to the client.

Ultimately the choice is yours. As long as you are setting up your business plan to take that choice into account (for example, you won't want to depend upon print sales if you are doing a "shoot and burn"), then there's no right or wrong answer. You'll hear some passionate arguments from both camps, but the reality is that there are plenty of successful photographers out there, and for as many photographers that you find who depend on print and album sales, you'll find as many who run their businesses based on digital file delivery as well.

OPPOSITE
It's best to discuss what sort of output your clients are going to want very early on in your process, as it impacts how you'll end the project, as well as how you'll charge for your services.

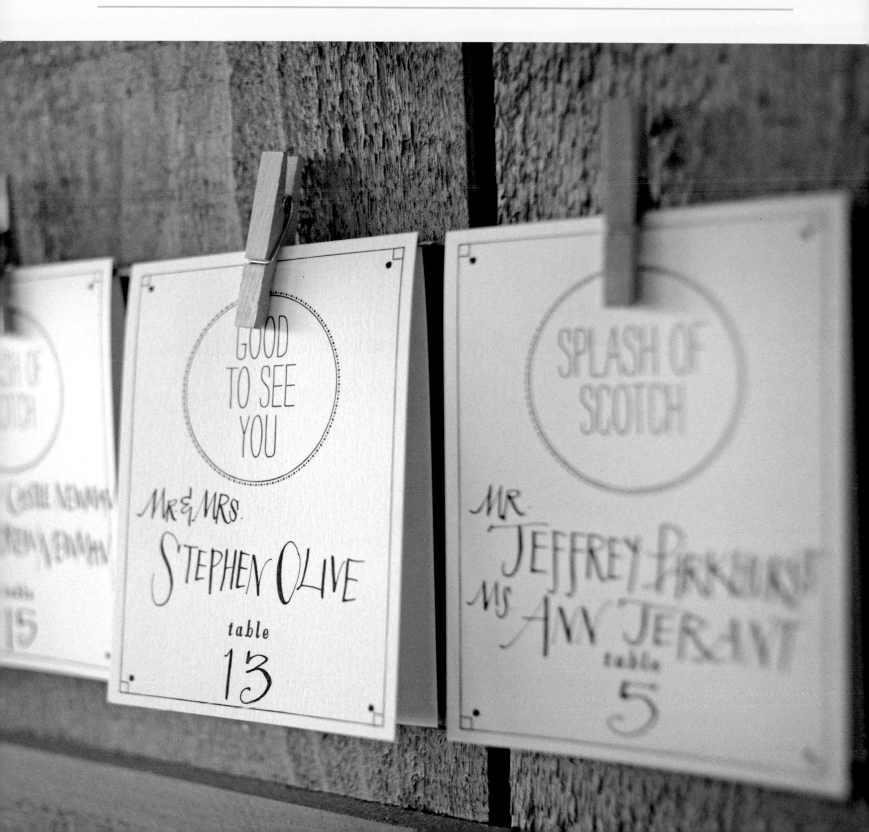

Post-production

WEBSITES, BLOGS, & ONLINE GALLERIES

It is essential to show your most recent (and best) work online. Whether you choose a blogsite, a traditional gallery website, or both, make sure that you are updating it.

I use my website as a gallery, and I send all potential clients there first. Then, if they'd like to see specific events or learn more about me or my process, I send them to my blog where I post all of my sneak peeks. Whatever you choose, make sure that you have a platform that showcases your work beautifully. I use PhotoShelter. It is a wonderful customizable website, and I pair it with a WordPress blog that uses a customized ProPhoto theme.

When I am ready to deliver images to the bride and groom, I set up a gallery, and they can then order their images from there. While I can create a gallery for my clients on my PhotoShelter website, I have chosen a different gallery site with a simpler user interface that

I prefer for proofing and ordering: Pixieset. It, too, is beautiful and customizable, and best of all, it is easy for my clients to use for viewing their images. They are generally sharing their online gallery with their family and friends (and my business is built on word of mouth), so I want my images to look the best they possibly can. My clients simply love it.

Pixieset also lets me upload high-resolution images, and I provide all of my wedding clients with the high-resolution digital negatives (JPEGs). While I sometimes provide a Dropbox link, I use Pixieset for clients who don't like the Dropbox interface. With Pixieset, they can download the images directly from their gallery, which keeps things simple. There are other online proofing and ordering websites that you can use (including PhotoShelter, SmugMug and Zenfolio) and they all offer a level of additional security since they allow you to back up the images offsite.

RIGHT TOP
I host my online galleries through Pixieset. It has a wonderful interface that is easy for my clients to use.

RIGHT BOTTOM
I use PhotoShelter for my website. It gives me a lot of flexibility when it comes to creating a specific look for the site, and the customer service is wonderful.

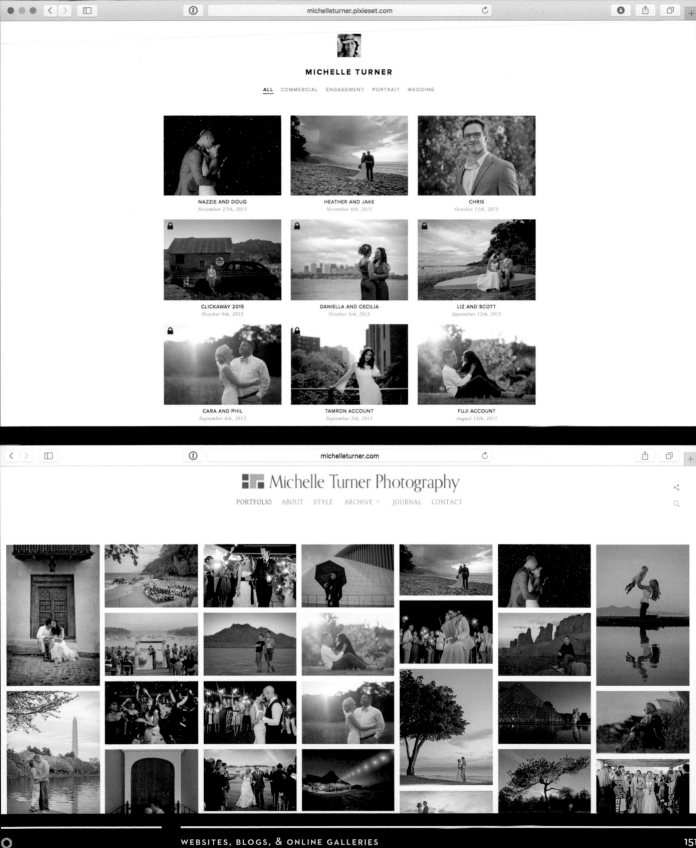

SOCIAL MEDIA

Many brides and grooms find (or at least follow) their photographers on social media, so it's important to update your social media accounts with your best and latest work. This shows your couples that you are shooting and that your work is consistent.

I'll start posting preview shots of a wedding on social media the day after I photograph it, via Instagram, Facebook, or Twitter. This serves another purpose as well; it keeps me connected to the industry and to a community of fellow photographers. I teach quite a few online photography courses and I speak at conventions, so I'll also show pullbacks and before and after images from time to time on social media. I do use Pinterest, but typically only to create private boards to help my clients with design or wardrobe ideas if they need them.

RIGHT TOP AND BOTTOM
Instagram is a great way to draw attention to your brand, as it is more about the beauty of each individual photo, and getting as many likes as you can (hint: use copious hashtags to distribute your photo as widely as possible). Facebook is, of course, quite similar, but allows extra features such as putting together albums, and even setting their privacy such that only the bride and groom can see them.

KEEPING IT FRESH: NETWORKING & MODEL SHOOTS

BELOW
I led a model-shoot workshop at Click Away (a wonderful photography conference) and was able to capture this image of the couple during a quiet moment between working with groups of photographers.

Perhaps you want to take your wedding photography to the next level, or maybe you just need some inspiration for an upcoming wedding. As artists, our style will change and develop as we change and develop. So, how do you keep it fresh? Try looking for inspiration from other mediums.

Go to a museum and appreciate how the masters of the Renaissance used light in their paintings. Look for inspiration in photographs outside of the wedding industry. The fashion industry can be a wonderful place to start if you are trying to refine your posing technique, for example.

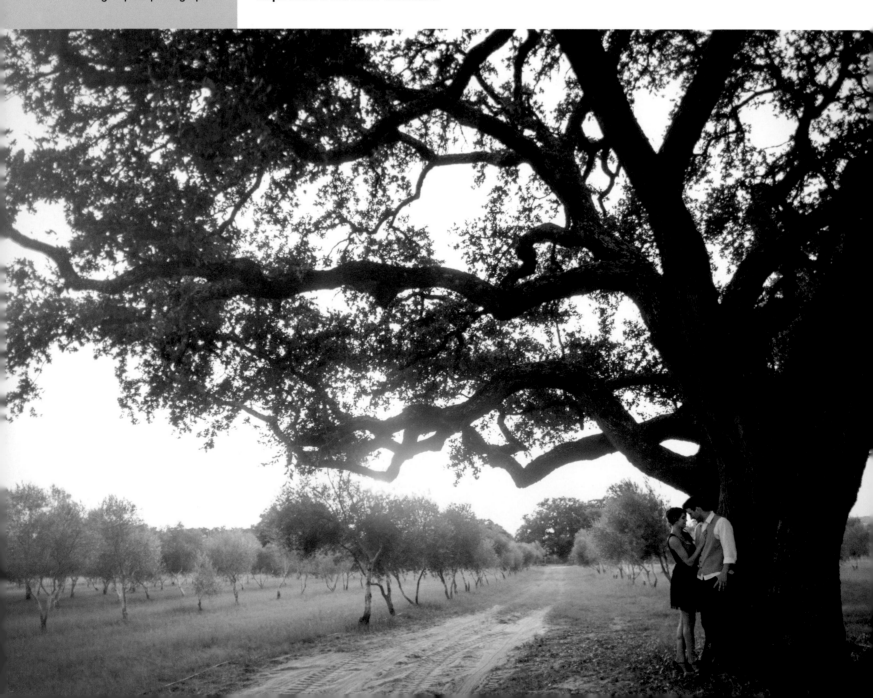

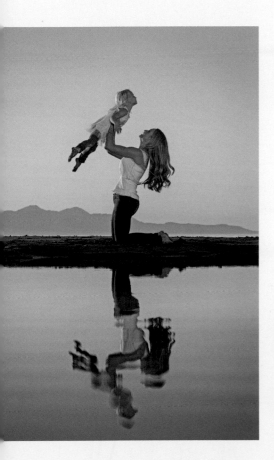

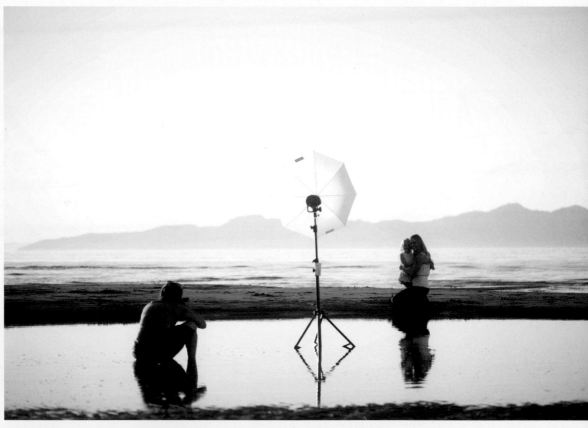

ABOVE LEFT & RIGHT
Photographing with other photographers can be
a wonderful experience. I shot the image on the
left during a creative shoot with my friend April.
She captured the pullback on the right to show
me shooting and illustrate where I positioned
my Profoto B1 to light my subjects.

INSPIRATION & ONLINE WORKSHOPS

I love looking at printed images. Don't get me wrong, I enjoy looking at images online, too, but there is something wonderful about admiring images in a beautiful book or magazine.

BELOW
If you're reading this book, you're already wise to the value of self-education. Online photo workshops are an extension of the same idea—it's amazing the skills you can learn without ever having to physically set foot back in a classroom.

My favorite photo mag is *Click*—the images are stunning and you'll find work from a variety of genres. Editor-in-Chief Cameron Bishopp Davis has a wonderful eye for finding talented photographers from around the globe. You'll also find a "Why It Works" section from Sarah Wilkerson. She breaks down the successful elements of strong images in every issue. This can be a wonderful way to learn more about composition and how to set up a strong frame.

Online workshops can also be a great way to learn a new skill. No longer do you have to spend days at an on-location workshop to take your photography to another level. You can learn everything from manual photography to composition to off-camera flash on your own time and from the comfort of your own home.

I am also the Director of Educational programming at the Click Photo School at Click & Company, where I teach two light workshops and manage dozens of other workshops on a variety of topics (www.clickphotoschool.com). Working in an online community for several weeks can get you to step out of the box and master a new skill with the support of your instructor, TAs, and peers.

Click

JANUARY / FEBRUARY 2015

Issue 11 • THE MAGAZINE FOR THE MODERN PHOTOGRAPHER

the creative
SPARK
A photographer's guide
to staying inspired

{Life's beautiful, photograph it!}

Daily
Magic

GOODBYE, PHONY!
Pose your subjects for real connection

Plus
BABY
PHOTOS
Must-have newborn displays

{photo project}
LAMB loves FOX
page 98

$5.95US $5.95CAN

0 2

0 74470 29256 2

myclickmagazine.com

Appendices

INDEX

ACKNOWLEDGMENTS

To Eric, Cody and Jackson—I love you guys so much! Thanks for being my support system, my inspiration, my sounding board, and the best part of my day, every day.

To Mom, Mike, Karen, and Brooke—Thank you for always supporting me and being willing to help out when I have to jump on a plane to shoot a wedding overseas or teach a class across the country. I appreciate everything that you have done for me and everything that you continue to do.

To Sarah, Kendra, April, Nina, Jen, Cameron, Jen, Amy, Bill, Kelly, Julia, Anne, and Monica—Thanks for the inspiration, the emoji, the endless brainstorming, the coffee advice, the enabling, and the daily laughs on Slack! I can't imagine working with a better team. You all inspire me to be a better photographer and artist.

To Adam, Frank, Francesca, Marina, and the whole team at Ilex— Thank you for entrusting me with this project. Your support means more than you know, and I appreciate all of your hard work!

To Anita and Dave—Thank you for helping me dream up crazy photo adventures and THANK YOU for always helping out when I have a last-minute project. You are such amazing friends.

To Linds and Adam —What an incredible decade it has been. Thank you for everything that you do to make my job so fun and easy. Big hugs to both of you!

Michelle Turner.